Inside Lightroom 2

Inside Lightroom 2

The serious photographer's guide to Lightroom efficiency

Richard Earney

Amsterdam • Boston • Heidelberg • London • New York • Oxford •
Paris • San Diego • San Francisco • Singapore • Sydney • Tokyo •

Focal Press is an imprint of Elsevier

This book is dedicated to Janette; for everything.

Focal Press is an imprint of Elsevier
Linacre House, Jordan Hill, Oxford OX2 8DP, UK
30 Corporate Drive, Suite 400, Burlington, MA 01803, USA

First edition 2009

British Library Cataloguing in Publication Data
Earney, Richard
 Inside Lightroom 2 : the serious photographer's guide to Lightroom efficiency
 1. Adobe Photoshop lightroom
 I. Title
 775'. 0285536

Library of Congress Catalog Number: 2008908020

ISBN: 978-0-240-81142-0

For information on all Focal Press publications
visit our website at www.focalpress.com

Printed and bound in Canada

09 10 11 12 12 11 10 9 8 7 6 5 4 3 2 1

CONTENTS

CONTENTS

Acknowledgements

There are many people to thank for helping this book to come to fruition. The Lightroom Engineering team, of course, deserve huge amounts of gratitude for producing this awesome piece of software. Mark Hamburg whose brainchild it was is *primus inter pares* in this; he will be much missed by the whole team and Microsoft are very, very lucky to have him!

Tom Hogarty, John Nack, Melissa and Troy Gaul, Thomas Knoll and of course the recently departed (from Adobe) George Jardine have all been extremely helpful throughout the whole process. George's Podcasts have been a source of inspiration for his many listeners.

Then there are the Lightroom buddies, Sean McCormack, Don Ricklin, Jeffrey Friedl, Lee Jay Fingersh, John Beardsworth, Mick Seymour, Mark Sirota, Roy Nuzzo, Victoria Bampton and Andreas Norén who have explored and discovered like no others! Special thanks to Don who has offered advice and corrected my bad 'ttypping' throughout the writing process!

My editors, Ben Denne, Haley Salter and David Albon who were encouraging and patient throughout the process and their predecessors Emma Baxter and Stephanie Barrett, who set me on the path.

To my late father who handed me his Minolta SRT-101 in a field in France when I was 11 years old and sent me off for a few hours to stave of holiday boredom with the aim of coming back with something interesting! I hope I finally managed it!!!

To my wife, Janette and my children Charlotte and Harry, who are forever waiting for me to catch them up as I take yet another photograph. I am sorry for being a perpetual 100 meters behind!

Janette has been my rock and the most important person in my life, I can only thank her for putting up with me!

Lightroom Basics

Adobe Photoshop Lightroom (Lightroom from here on) is now in its second full release, having been through a long and protracted birth, two Public Beta releases and the gaining of a devoted and vociferous community. Yet there is still a bit of an air of mystery about the application. Many users are still puzzled what it is for; others wonder why 'obvious' features are missing and more ask whether it should just become part of Photoshop or Bridge!

This book is aimed at users who want answers to these questions as well as explaining new features, the tools at their disposal, and offering workflow scenarios. It isn't trying to be a comprehensive manual, (there are other authors who have written books that take care of that segment of the market!) rather it is a look at the way Lightroom works and behaves and how best to make it work for you.

Lightroom is an exciting tool that offers a different methodology from previous tools in this area and we will be exploring how this methodology affects how you work.

Splash Screens

Lightroom has an alternative splash screen as well as the one seen below, which reflects its codename during development, Silvertone. Press the R key when the main Splash Screen is in view to see it.

It is not as interesting or amusing as the version 1.0 screens, which were 'Pirates of the Caribbean' themed.

In this chapter we will look at the history of Lightroom, what it is for and who it is aimed at, run through the basic interface and discuss Lightroom's color management capabilities. Other chapters will look at the new features in Lightroom 2, a way of structuring your files to ensure a smooth workflow, import strategies, and how to work in the develop module

The vital topic of backup, archiving and management of offline media will be looked at, with some practical solutions offered to ensure that users will feel their valuable assets are being looked after. There is a major section on the use of Presets in all aspects of Lightroom. Develop Presets, especially, have proved to be a highly popular part of Lightroom, as they are easy to create and share. There is a thriving community of preset creators who share their work for free or ask for some recompense. We will look at these resources as well as the wider Lightroom community who offer help, debate and thoughtful comment on the application.

Conventions

Throughout this book I will use screenshots and shortcut descriptions to guide you through the areas of the application. As I am a Mac user, I will show Mac screenshots and refer to Mac shortcuts. This isn't meant to be an insult to Windows users, it is just more convenient for me!

The application is cross-platform, the serial number works for Mac and Windows, so where I mention **Cmd**, Windows users should read **Ctrl**, and where I mention **Option**, Windows users should read **Alt**. I will, however, use the term **Right-Click** to bring up the contextual menu. This is generally thought to be a Windows-only action, but has been part of the Mac operating system for

Fig. 1.1 The Adobe Photoshop Lightroom 2 splash screen. Some useful information is kept here; the Build Number and the version of Camera Raw used by Lightroom.

many years. Apple sell a multi-button mouse (the 'seemingly' one-buttoned Mighty Mouse) so I think the convention is well established. However for those who *are* still using a one-buttoned mouse, to bring up the contextual menu just **Ctrl-Click**!

What is Lightroom?

Lightroom is an end-to-end photography workflow tool, primarily aimed at digital photographers, but can also be used by analog photographers who have digitized their collections. It is for professionals and serious amateur photographers. This is not to say that it can't be used by any photographer with a digital camera, but to get the best out of the application you will ideally be shooting with a camera capable of producing Raw files; this caters for almost all Digital SLRs, Digital backs and a growing number of compact digital cameras.

Non-Destructive Workflow

Non-destructive workflow is a great marketing term, that can be easily abused. In terms of Lightroom it refers to the software's method of applying edits to an image. Rather than editing pixels as previous generations of software have, it treats your original file as sacrosanct and stores the edits you make in a separate file or in a dedicated space within the image file. You are able to transverse the full history of your edits, return to the original state, make virtual copies or export with a variety of settings and the original image will still be as intact just as when you took it. The other term for this, which you will hear mentioned is Parametric Editing.

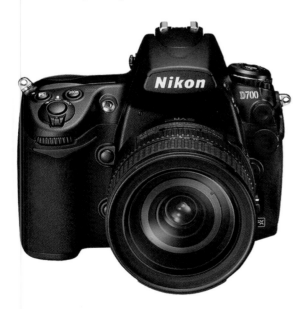

Fig. 1.2 The Nikon D700, a modern high quality DSLR camera capable of shooting in Nikon's Raw format (NEF) and JPEG.

The other file formats supported by Lightroom are DNG (Adobe's Digital Negative format), TIFF, JPEG and PSDs (Photoshop's native file format) with maximize compatibility selected. These are all the main formats that digital cameras have shot, since there invention apart from the Photoshop file format, which is included for compatibility with Photoshop.

How Lightroom came to be

Lightroom was essentially a research project into conceptualizing new types of digital imaging software carried out by Mark Hamburg. Mark had been one of the lead engineers on Photoshop, but wanted to explore ways of interacting with photographic imagery. Working with a small team, he produced several protoype interfaces for working with imagery in a non-destructive way. The project, known as Shadowland, eventually became Lightroom. The Shadowland Development story can be read at the following address.

http://tinyurl.com/p8a6e

Mark Hamburg left Adobe before the release of version 2.0, to work at Microsoft on their User Experience

Lua

Lua is a powerful, lightweight embedded scripting language that Lightroom incorporates. While conventional programming languages are used to create the program, Lua has been integrated in order to assist with scripting and output. More information about Lua can be found at http://www.lua.org/. There is a two part interview with Mark Hamburg which explains some of the uses of Lua in Lightroom.

http://tinyurl.com/6pjv7o
http://tinyurl.com/2 \times 8aaa

Lightroom extends its parametric editing capabilities to these other formats, which means that even a JPEG is treated as a 'master' image, not to be touched.

Lightroom is also designed to answer one of the most commonly asked questions that photographers have when they start shooting digitally, which is 'How do I manage the vast numbers of images I am now shooting?'. With today's digital cameras it is very easy to shoot hundreds or even thousands of images in a day. The ability to manage and 'process' a huge number of images is of paramount importance to the modern day photographer.

The way Lightroom deals with this workflow conundrum is to divide the application into modules which separate the common processes into coherent sections. For some, this is the main attraction of Lightroom, others can find this modularization slightly awkward. Hopefully some of the workflow scenarios presented in this book will show ways of working that break down these barriers.

The modules offered (in their natural workflow order) are Library, Develop, Slideshow, Web and Print. But there are more 'hidden' modules that are just as important, Import and Export.

Library takes care of the selection, storage, file management, and metadata. The Import and Export modules are encompassed by the Library, but both work across the application.

Develop offers powerful features to enable you to extract the maximum quality and detail out of your images as well as allow you to retain creative control for artistic interpretation.

Slideshow allows on screen presentations of your images, offering the ability to export your slideshows to a PDF file and to a collection of JPEG files (useful for creating an auto run CD).

Web is, naturally, the module you use to create web galleries. There are several galleries provided with Lightroom, but one of the thriving areas of community development is the creation of new galleries. Some are commercial products and others are free or donationware. A technical user can also dive into the code and create their own, but you need a solid knowledge of HTML, CSS, XML, XSLT and potentially the Lua scripting language.

Finally, the Print module controls output to printed media. Lightroom offers a large amount of print control compared with other applications, using presets to save printer settings and profiles for repeated use and attempting to control manufacturers' printer drivers to a greater extent than before.

Why choose Lightroom?

Lightroom is not the only application out there that offers some of these features, Apple's Aperture and even Adobe's Photoshop offer some or all of the functionality of Lightroom. So, in part, the choice will be down to you and what you feel comfortable with. For those users who have Photoshop CS3 and above, Lightroom may seem to replicate a lot of functionality, and you would be correct to think that, but Lightroom's advantage is its packaging of the photographic functionality of Photoshop, Bridge and Camera Raw into one application with some added benefits.

If you are currently a Photoshop CS3 user, you possess applications that offer similar features to Lightroom's modules. Bridge is, in passing, and equivalent to the Library and Slideshow modules, the Camera Raw Plug-in is equivalent to the Develop module and Photoshop offers Web, Print (although at a slightly lesser level) and Export functionality compared with the Slideshow, Web and Print modules.

Fig. 1.3 The Lightroom Workflow. Import from card; files are stored and a database is created or utilized. The Library is the visual representation of your files. The Develop module is used to refine your images for output to Slideshow, Web, Print and Export.

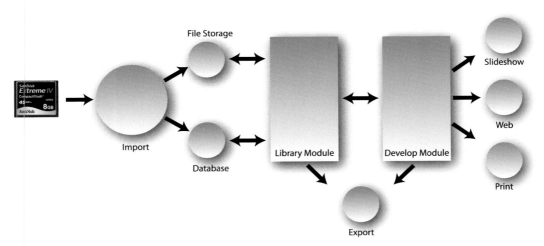

File Storage

Import

Database

Library Module

Develop Module

Slideshow

Web

Print

Export

7

Fig. 1.4 The Adobe Bridge interface.

However, Lightroom's selling points are that it is an all-in-one package, it is solely aimed at photographers, and it uses a database to offer metadata, cataloging and searching capabilities way beyond those of Bridge. All the editing takes place parametrically, whereas once you have brought an image into Photoshop, you are editing at the pixel level. (This can be mitigated by using Adjustment Layers and Smart Filters, but most image editing in Photoshop will have a measure of destructiveness.

Photoshop is a massive and wonderful application, but photographers are a small part of its user base, so there are many features in Photoshop that will never be needed. Since Photoshop is a part of the Creative Suite there is an expectation that it is part of a suite aimed at Illustrators, Designers, and Art Directors, as well as Photographers.

Over the years the code-base has become enormous and complex, whereas Lightroom is programmed to be agile and easily extensible. A good example of this is that Adobe was

relatively easily able to make Lightroom run in 64 bit mode, but has found the job much harder in Photoshop. The Mac version of Photoshop won't be 64 bit until version CS5, whereas the Windows version will be in CS4.

Bridge is also designed to be more than a photographic application. Its aim is to be a media cataloging and management tool for the whole of Adobe's Creative Suite, so it is capable of managing PDFs, EPS, InDesign, Flash files, Web graphics and more. It was originally a simple file browser and while it has grown up to be a more useful application than that, it is still aimed at a different purpose than Lightroom. If you had to compare it with another application iView Media Pro (or as it now is Microsoft Expression Media) would be the nearest equivalent. iView certainly used to be the darling of the Digital Asset Management world, but the impression is that is has suffered under the ownership of Microsoft.

Lightroom's original goal was to aim for 'unreasonable simplicity' in its approach. Version 2 has, of course, gone a bit further than that, but the engineers still use this as their mantra when adding new features. Sometimes this can lead to puzzling omissions from the feature set; version 1 came without dual monitor support which led to some users complaining that the software was 'unusable' because it lacked it. But the reasoning was that the application *was* perfectly usable without it and because it had been designed to work with one monitor there was no 'absolute need' to include it. So if a feature was deemed a nice-to-have rather than a 'must have', it might not make it into the feature set.

Version 2 has relaxed this strict attitude somewhat but there are still features that some users consider 'essential' that are missing. Partly this is due to the aforementioned unreasonable simplicity rule and partly because the Lightroom team is relatively small compared with others in Adobe. This coupled with release date time constraints tends to lead to some 'interesting' exchanges between users on the various forums dedicated to Lightroom!

Lighroom is a stand-alone application, but is also beholden to simultaneous releases with Adobe Camera Raw, and Lightroom releases generally can't get in the way of Photoshop releases. Lightroom tends to be on a more frequent release schedule than Photoshop, which tends to be updated every 18 months. So there are extra pressures on the Lightroom team to release in a timely fashion.

Adobe and 64 bit applications

For more information on Adobe and 64 bit Photoshop, see John Nack's blog entry: **http://tinyurl.com/2owbpy** and for more on 64 bit computing and the advantages and disadvantages in Photoshop see 'Living Photoshop':**http://tinyurl.com/yusmq9**

Lightroom and Adobe Camera Raw

I mentioned a few paragraphs ago, that much of the same functionality that exists in Lightroom also exists in Adobe Camera Raw (ACR). The reason for this is that Lightroom uses the Camera Raw processing pipeline, so in effect it is Camera Raw with extra features and a natty user interface!

There are some differences. In their current incarnations (Lightroom 2 and ACR 4.5) Camera Raw lacks the new Adjustment Brush and Graduated Filter correction tools. Lightroom's Develop module lacks one thing from Camera Raw which is Point Curve editing tools.

Apart from feature parity (or near parity) Camera Raw and Lightroom are also released simultaneously because they both have to support the same models of camera.

Fig. 1.5 Adobe Camera Raw 4.5. Point Curve Editing.

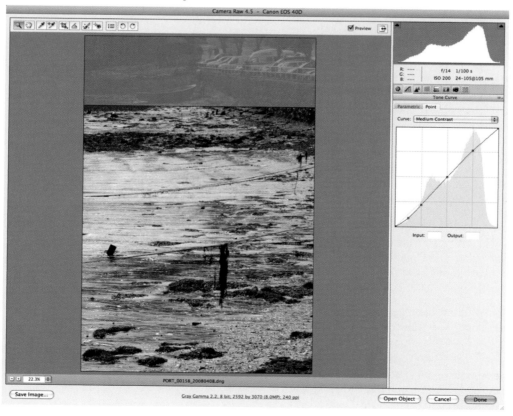

Camera Support

Camera support is one of those areas where third party software developers generally have to play catch up. This is not only frustrating for the developers, but also for the users of that piece of software who might rush out to buy the latest and greatest camera, only to find that their favorite software doesn't support it yet. How does this come about?

When a new camera is released the camera manufacturer updates their Raw file format and their software to support this Raw file. What they rarely do is give out any of this information to anyone. As far as they are concerned the Raw file is their intellectual property and their software will get the most out of that file.

If only that was true! Most software provided by the manufacturers can be charitably described as average! They are often slow, and the user interface is normally clunky and sometimes the software doesn't provide the best rendition of the Raw file.

Various third party software companies have produced their own Raw Converters, and they have to go to a lot of trouble to decode the behavior of the Raw files. They are not allowed by law to reverse engineer the file formats, so they have to find other ways to do the decoding.

ACR came about because the author, Thomas Knoll (who also created Photoshop with his brother John) was on holiday with his new camera and ended up so frustrated with the Canon Raw Converter software, that he wrote his own, as you do!

You can read about the creation of Camera Raw on the Photoshop Widow's website: **http://tinyurl.com/6k7tsk**.

This piece of software matured into the very first release of ACR. Thomas's method of 'cracking' the Raw code was to create two profiles for the camera; one created under D65 lighting, the other under 3200K tungsten. He then used a Color Temperature slider to interpolate between these two profiles.

This has proven to be a really good way to get the right results for several years. But it isn't perfect, so there was an allowance built into subsequent versions for adjusting calibration sliders, so that you could compensate for unit to unit variations.

With the release of ACR 4.5 and the DNG Profiler, there is now the capability to create and update your own profiles, for ultimate color rendition and fidelity. See Chapter 3, What's New in 2?

dcraw

Dave Coffin writes dcraw which is a UNIX based application for converting Raw files. As he says, when it is 'used skillfully, [it] produces better quality output than the tools provided by the camera vendor.'

Lightroom uses elements of dcraw for decoding Raw file formats.

http://tinyurl.com/6yaf

Every time a new model, or models, comes out the basic profiling has to be done for these new cameras, and updated versions of Camera Raw and Lightroom are released. On average these releases happen 3–4 times a year. This nicely coincides with the major photographic shows, so each release should manage to cater for the newest cameras.

Camera Support in ACR 4.5/Lightroom 2.0

Since it is an often asked question, here is a list of the cameras supported in ACR 4.5 and Lightroom 2.0. By the time you read this Photokina 2008 will have taken place, so there will be a whole new set of cameras released and they will be supported by ACR and Lightroom within a short period of time. So in effect this list will be out of date soon, but as a snapshot it will help put into perspective the wide range of support that exists in Camera Raw.

Supported Cameras in ACR 4.5/Lightroom 2.0

Canon
EOS-1D
EOS-1Ds
EOS-1D Mark II
EOS 1D Mark II N
EOS-1Ds Mark II
EOS-1D Mark III
EOS-1Ds Mark III
EOS 10D
EOS 20D
EOS 20Da
EOS 30D
EOS 40D
EOS 5D
EOS D30
EOS D60
EOS 300D (Digital Rebel/Kiss Digital)
EOS Rebel XT (EOS 350D/EOS Kiss Digital N)
EOS 400D (Rebel XTi/EOS Kiss Digital X)
EOS 450D (Digital Rebel XSi/EOS Kiss X2)
PowerShot 600
PowerShot A5
PowerShot A50
PowerShot Pro 1
PowerShot S30
PowerShot S40
PowerShot S45
PowerShot S50

PowerShot S60
PowerShot S70
PowerShot G1
PowerShot G2
PowerShot G3
PowerShot G5
PowerShot G6
PowerShot G9
PowerShot Pro70
PowerShot Pro90 IS

Contax
N Digital

Epson
R-D1
R-D1s

Fujifilm
FinePix E900
FinePix F700
FinePix IS-1
FinePix S100 FS
FinePix S2 Pro
FinePix S5 Pro
FinePix S3 Pro
FinePix S20 Pro
FinePix S5000 Z

FinePix S5200/5600
FinePix S6000fd/S6500fd
FinePix S7000 Z
FinePix S9000/9500
FinePix S9100/9600

Kodak
DCS 14n
DCS Pro 14nx
DCS720x
DCS760
DCS Pro SLR/n
EasyShare P712
EasyShare P850
EasyShare P880

Konica Minolta
Alpha Sweet Digital (Japan)
Alpha-5 Digital (China)
DiMAGE A1
DiMAGE A2
DiMAGE A200
DiMAGE 5
DiMAGE 7
DiMAGE 7i
DiMAGE 7Hi
Maxxum Dynax 5D (Europe)
Maxxum 5D (USA)
Maxxum 7D/Dynax 7D

Leaf
Aptus 17
Aptus 22
Aptus 54s
Aptus 65
Aptus 75
Aptus 75s
Valeo 6
Valeo 11
Valeo 17
Valeo 22

Leica
D-Lux 2
D-Lux 3
Digilux 2
Digilux 3
V-LUX 1

Mamiya
ZD

Nikon
D1
D1H
D1X
D100
D200
D2H
D2Hs
D2X
D2Xs
D3
D300
D40
D40x
D50
D60
D70
D70s
D80
Coolpix 5000
Coolpix 5400
Coolpix 5700
Coolpix 8400
Coolpix 8700
Coolpix 8800

Olympus
E-1
E-3
E-10

E-20
E-420
E-520
EVOLT E-300
EVOLT E 330
EVOLT E-400
EVOLT E-500
EVOLT E-510
C-5050 Zoom
C-5060 Zoom
C-7070 Wide Zoom
C-8080 Wide Zoom
SP-310
SP-320
SP-350
SP-570 UZ
E-410
SP-500UZ
SP-510 UZ
SP-550 UZ
SP-560 UZ

Panasonic
DMC-FZ30
DMC-FZ50
DMC-L1
DMC-LC1
DMC-L10
DMC-LX1
DMC-LX2
Lumix DMC-FZ8

Pentax
*ist D
*ist DL
*ist DL2
*ist DS
*ist DS2s
K10D (PEF)
K100D
K100D Super
K110D
K20D (PEF)
K200D (PEF)

Phase One
H 20
H 25
P 20
P 20 +
P 21

P 21 +
P 25
P25 +
P 30
P 30 +
P 45
P 45 +

Samsung
GX 1S
GX-1L

Sigma
SD9
SD10
SD14

Sony
DSC-F828
DSC-V3
DSC-R1
A100
A700

Native DNG Support

Hasselblad
H2D

Leica
Digital-Modul-R
M8

Pentax
K10D
K20D
K200D

Ricoh
GR Digital
GR Digital II
GX200

Samsung
GX-10
GX-20
Pro 815

Provisional Support in ACR 4.5

Canon
EOS 1000D (Digital Rebel XS/Kiss F)

Nikon
D700

Digital Negative format

Adobe's website, contains documentation and white, papers relating to DNG, including the SDK. http://tinyurl.com/rw8sx

A comprehensive commentary on matters relating to DNG is provided on Barry Pearson's website, including perspectives on the failed OpenRAW initiative. http://tinyurl.com/otrb4

Every full release of Camera Raw, apart from v1.0, is released with a new release of Photoshop. The older Plug-ins will not work in the newer version. This leads to howls of protest from users who have just bought a new camera, but don't want to upgrade their version of Photoshop as well, but fortunately Adobe has a solution and that is DNG.

DNG

DNG, or Digital Negative, is a wrapper format for Raw files and is aimed at being a universal camera file format. When you have files from your new camera, but don't have the latest version of Camera Raw, you can download the latest DNG Converter, convert your Raw files to DNG, and continue to use them in older versions of Camera Raw. You can also use Lightroom to batch convert Raw files to DNG.

DNG was created in 2004 by Adobe, to try to find a common file format that everyone in the community can use, from manufacturers to users. A few years on from its introduction, some manufacturer's cameras write to DNG natively and others, notably Canon and Nikon, refuse to support it.

DNG was also created so that Raw file formats can be supported long after the manufacturers have ceased to support the files.

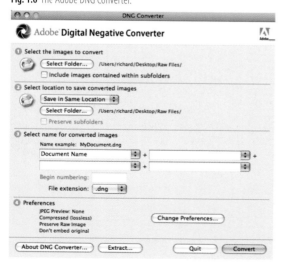

Fig. 1.6 The Adobe DNG Converter.

Now it may seem incredible that they wouldn't, but Kodak files are not supported by any software from Kodak and Canon even dropped support for one of their models. They had to add support again as there were many protests!

The DNG specification is currently up to version 1.2.0. This version incorporates the new color profile abilities seen in ACR, **http://tinyurl. com/4cv89e**.

As digital photography is still in its infancy issues of longevity and protectionism are still being discussed. DNG aims to make such issues less of a worry. Adobe have offered the format to the community for free and have offered to donate it to a standards body.

The Lightroom Interface

The Lightroom interface is a modular one, as mentioned earlier, and in this book we will be referring to the various sections, so it seems appropriate to explain which bits I will be referring to!

Library Module

Below is the Library Module, with the various sections shown and some of the basic shortcuts.

Loupe View

Pressing the **E** key, the **Return** key or the **Spacebar**, takes you into Loupe mode. The size you view the image can be changed from **1:4** to **11:1** (a subtle homage to the movie Spinal Tap).

Compare View

Press the **C** key and you can compare two images side by side for evaluation. You have the option of zooming in in synch or not, swapping the images, rating, picking and rejecting.

Survey View

Press the **N** key to move into Survey View. This allows you to compare several images with the active photo. The active photo is displayed with a white border surrounding it.

Develop Module

Reached by pressing the **D** key or **Cmd Option 2**, this takes
you to the main area for adjusting your images. You can also
use other keyboard shortcuts to enter specific sections of the
Develop module from the Library Module, such as **R** to enter the
Crop Tool.

Slideshow Module

Reached with the press of **Cmd Option 3**, this is the area for creating Slideshow presentations for clients.

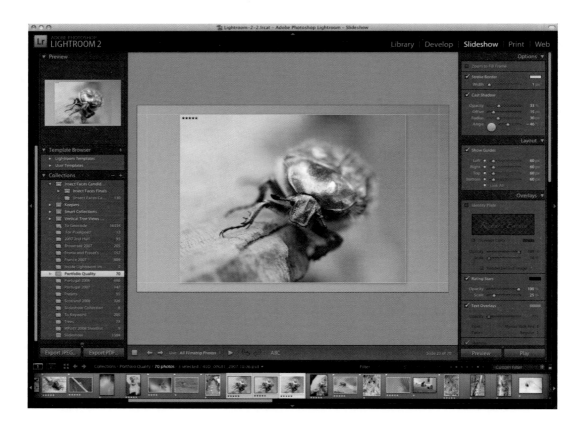

Print Module

Pressing **Cmd Option 4** leads you to the Print Module to set up printing to media.

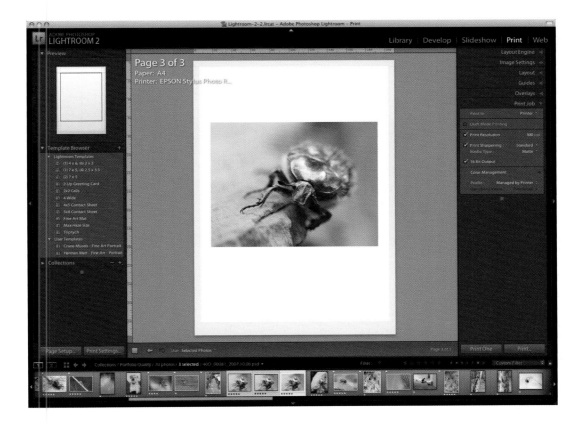

Web Module

Finally, the Web Module is reached by pressing **Cmd Option 5**, allowing you to create Web Galleries for posting to your website.

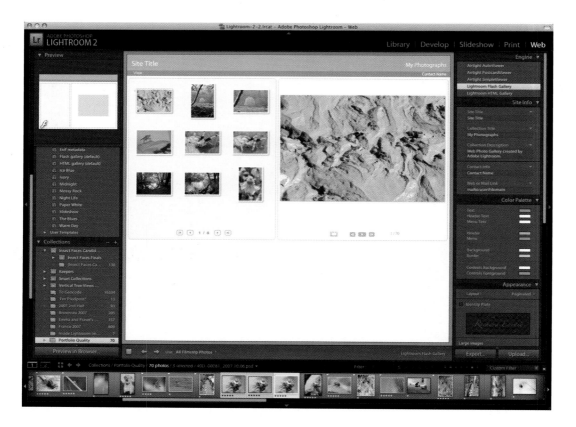

A complete list of keyboard shortcuts is available from the Lightroom Queen website, Mac: **http://tinyurl.com/65xfdv** and Windows: **http://tinyurl.com/4tztwu**.

Pressing **Cmd/** in a module will give you shortcuts for that specific module.

The Import and Export Modules

Although not strictly separate modules as the other five are, the Import and Export Modules are a vital part of Lightroom's

capabilities. To invoke the Import process you can either press
Cmd Shift I, press the **Import** button, selecting from the various
options in the **File** menu or, if set up to do so, it will automatically
appear if a memory card is inserted to an attached card reader.
Imports can be of files from a card, already on disk or from an
Exported Catalog.

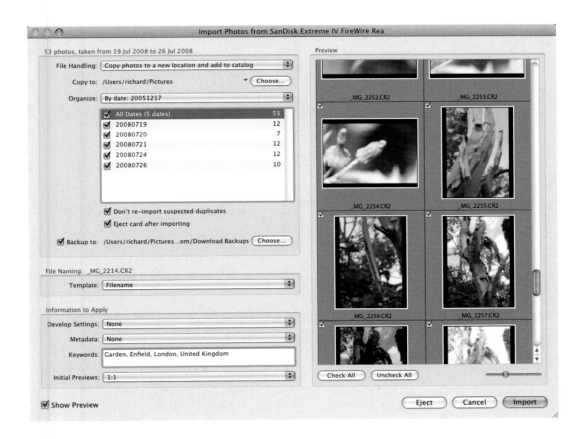

The Export Module is invoked when pressing Cmd Shift E,
pressing the Export button, or selecting from the various options
in the File menu. Exports can be setup from scratch, performed
exactly as the previous export, or performed using an existing
Preset. These Presets are set in the Export dialog box and more
information is found in Chapter 6, Lightroom Presets.

Lightroom and Color Management

One of the issues that befuddles newcomers to Lightroom is the supposed lack of color management. Whereas Photoshop will warn you about missing or different profiles, Lightroom stays silent.

The reason for this is that Lightroom handles color management for you, allowing you to just get on with managing and developing your files.

Raw files, of course have no color space embedded in them, whatever you set on your camera. Lightroom takes advantage of this and imports any Raw file in its own color space. This is a very large color space, known as Melissa RGB which is a modified version of ProPhoto RGB. It uses the same chromaticies (the color coordinates) but not the gamma. LR's gamma internally is gamma 1.0 (as opposed to the usual for ProPhoto RGB which is gamma 1.8. The histogram display is a tuned sRGB tone curve.

One reason for using this space is so that all the color information contained in your Raw files can be handled by Lightroom with plenty of headroom for adjustments and the general high-bit processing that can be performed.

The other advantage of using a space as large as that of ProPhoto is about maintaining the distinctions between all of the out of gamma colors, so that you can map them into printable space as gradations rather than blobs.

If a file is imported that is not color managed and is not a Raw file then Lightroom will assume it has an sRGB profile.

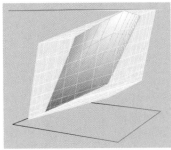

So Lightroom just manages your color spaces for you and you only have to think about them on export. The (very) general rule of thumb then is: if you are editing further in Photoshop then choose ProPhoto RGB; if you are exporting to the web then choose sRGB and if you are supplying for print you might want to choose Adobe RGB (1998). But that very loose recommendation probably doesn't cater for much beyond the basics!

Fig. 1.7 Color spaces compared: ProPhoto RGB vs Adobe RGB; Adobe RGB vs sRGB; ProPhoto RGB vs sRGB.

Color Management is a huge topic outside the scope of this book and much more information can be found in a companion volume from Focal Press, *Color Management for Photographers* by Andrew Rodney.

This concludes the basic tour of Lightroom's methods and capabilities. The next chapter looks at setting up the ideal system to utilize the power of Lightroom.

The Ideal System

As with most applications the minimum specs for hardware to run Lightroom are fairly optimistic. It is, of course, perfectly possible to run Lightroom on a lower end computer, but you really won't be getting the best out of it, you will probably end up waiting a lot and drinking too many cups of coffee!

This chapter will look at setting up a computer to run Lightroom from scratch, as well as for those who have systems and are looking for ideas of how to get the best performance gains.

If you have decided that Lightroom is your Digital Photography management tool of choice and are looking to create the ideal system, what should you be looking to buy?

I have always taken the view that when looking to purchase computer hardware, you have to aim for as much power as you can that is only just out of your budget.

What does this mean for you and your pocket?

Well, unless you have unlimited spending power, and therefore can afford the best, most powerful and expensive setup, you are likely to have to make compromises, but the way I approach it is that if your compromise budget is, say, £2000 but you know that spending

Lightroom Minimum Specs

Macintosh

PowerPC® G4, G5, or Intel-based Mac

Mac OS X v.10.4, 10.5

1 GB of RAM

1 GB of available hard-disk space

1024 × 768 screen resolution

CD-ROM drive

Windows

Intel® Pentium® 4 processor

Microsoft® Windows® XP with Service Pack

2 or Windows Vista™ (Vista 64 bit edition support)

1 GB of RAM

1 GB of available hard-disk space

1024 × 768 screen resolution

CD-ROM drive

Fig. 2.1 Apple MacPro. *Image courtesy of Apple.*

another £250 will get you something extra that will improve speed or allow you greater storage or expansion capabilities, it is probably worth doing. The amount you invest at the beginning of the process may well be rewarded down the line with more expansion capabilities and most importantly greater longevity.

Whether you are a professional photographer or an advanced amateur, the ideal is to be able to use your computer setup for 3 years at least, after which migrate the computer down for other uses or to other family members. If you have to swap more frequently, you have either under specified at that beginning or some major unforeseen advance in technology has occurred that made the change impossible to avoid. I assume that over time you might upgrade RAM, cards or storage as needs change.

So with that in mind, purchasing a system for Lightroom needs to look at what Lightroom most benefits from. Lightroom loves RAM, it loves multi-core processors and it will need a large amount of disk space; not to run the application, but for image storage. The monitor card is important but slightly less of a concern. As long as you have a good enough card to run a dual monitor setup you should be fine. Lightroom doesn't make as much use of graphics acceleration as its rival Aperture does, for example.

It is also necessary to factor into the equation storage and archival capability, because these are vital to any digital photographer. Having one unbacked up copy of your digital images is a disaster waiting to happen!

Computers

I won't make strong recommendation as to computing platform or specific computers to buy. Both are matters of personal choice, I prefer the Apple Macintosh platform and would recommend them for a number of reasons, but Lightroom is a cross platform application so running it on a Windows PC is quite acceptable. In fact you can even mix and match; the Adobe license allows you to run a desktop and a laptop copy of the application on one serial number and one can be a Mac and one a PC. Many photographers will have a laptop for in the field work and a desktop back at base, one of these might be a Mac and the other a PC.

64 bit

Lightroom is also a 64 bit application, so it is worth considering whether you will benefit from choosing to use Mac OS X 10.5+

(If you buy a new machine, you won't have a choice, as it will come with it preloaded!) or Windows Vista 64 bit (XP 64 bit is not recommended). The Windows installer detects if you are running a 32 bit or 64 bit system, it is possible to override its choice, although I am not sure why you would want to! You will have probably guessed already, but if you can utilize or buy a computer and operating system that can do 64 bit computing you really should for Lightroom work. There are noticeable speed gains and you will also be able to address more RAM.

To ensure you are using the 64 bit version of Lightroom on the Mac, firstly you will need to be running an Intel based Mac with Mac OS X 10.5x (the latest being 10.5.5 at the time of writing) also known as Leopard. Find your copy of Lightroom (normally in the **/Applications/** folder.

Click once on the icon and select **Command I** or right-click and select Get Info. The default in the General section of the Get Info window is to **'Open in 32 Bit Mode'**. Uncheck the box and either start or restart Lightroom and you will be in 64 bit mode. If you don't see this option, then your Macintosh isn't capable of running 64 bit applications.

Fig. 2.2 Dell Precision™ T7400. *Image courtesy of Dell Inc.*

Fig. 2.3 Running Lightroom in 64 bit mode on the Mac. Select the Application in the Finder. Press Command 1. Uncheck Open in 32 Bit Mode. Start or Restart Lightroom. The Splash Screen will show you running in 64 Bit Mode.

Fig. 2.4 RAM cips in a motherboard.

RAM

RAM is always crucial. Bearing in mind that you need at least 1–2 GB of RAM just to run an operating system with comfortable overhead, you are really looking at a minimum of 2 GB with no real maximum other than the limits of your motherboard and the amount your OS can use. On different Macs I have found that performance really is affected by RAM. So a 2.4 GHz MacBook with 2 GB RAM performance is fast, but upgrading to 4 GB really helps. If nothing else you can also run other applications at the same time! PCs obviously address memory slightly differently, but the principles remain similar; 1–2 GB for the Operating System and anything else for applications. RAM is relatively cheap so stinting on it makes little sense when the benefits are so obvious.

On my main desktop computer which is a MacPro with 10 GB RAM again performance is excellent – but then it is also a 3 GHZ 8-core computer, so one should expect great performance! Other heavy Lightroom users such as Jeff Schewe (photographer and advisor to Adobe) have gone the whole hog and stacked their computers with 32 GB RAM! Which should be enough to run the most demanding of applications!!

Processors

So more RAM is really helpful and, as alluded to in a previous paragraph, a fast processor helps, but what really helps is the modern trend to multi-core processors. Lightroom is multithreaded, multitasking and programmed to take full advantage of modern processor technology. You can fire off multiple processes in Lightroom; exporting, creating a web gallery, rendering previews and Lightroom will handle it, but with a 4-core or 8-core processor setup this will be handled with great ease. The general recommendation is to go with an Intel dual- or quad- core plus processor. AMD processors have a good reputation for 'bang per buck', but there have been odd reports of problems, which may be due more to home built systems or some other problem, but I just offer it as an observation.

Fig. 2.5 Intel Xeon Processor. Image *courtesy of Intel* ®.

Storage

So RAM and fast, multi-core processors are great, a fast subsystem will also help, but storage is equally important.

I recommend big, fast hard drives. Preferably using SATA or even SAS (Serial Attatched Storage). If you have internal drive bays you

can fill them with fast 1 TB drives for a very low price. Ideally you will also want to be looking at drives that spin at 7200 rpm or more.

Many laptops come with 5400 rpm drives and while they tend to have larger capacities Lightroom is again happier with a faster speed drive. The disadvantage of faster speed drives in a laptop is that they have a detrimental effect on battery life, but that may be a price worth paying, especially if you use your laptop powered from the mains.

The important things to think about with storage is that you need a lot of space for images – bear in mind that files produced by DSLRs/Medium format backs range these days between 10 MB and 50 MB, you will soon eat into even a 1 TB drive if you are photographer who shoots a lot.

Lightroom also uses a database (.lrcat) and stores preview data in a separate file (.lrdata), so this has to be factored into storage considerations as well. You will set how large the Previews should be and how you want to manage them before you start using Lightroom and we will deal with this later. A Lightroom database *can* grow in size quite quickly, and ideally you need enough space on the drive for continued expansion of the folder containing these files. It is also recommended to keep this folder on the fastest drive in your collection, as it speeds up access to the Previews.

In Figure 2.7, you see the space taken by a small-sized catalog, a medium-sized Catalog and a larger-sized Catalog. The second one contains fewer Previews but is larger, it has not been optimized recently. The largest one contains a 1:1 preview of every image, so is nearly 27 GB in size! This Catalog also contains only 12 000 images. Some Lightroomers have Catalogs that contain over 10 000 images

Regular Database backups mean that you will always have a close duplicate of the .lrcat. But it is also worth adding this folder to your regular backup regime onto a different drive as mentioned below.

Fig. 2.6 Internal Hard Drive. *Image courtesty of Hitachi.*

Fig. 2.7 Three Lightroom Catalogs and the associated Preview files.

	Name	Size
Small Catalog	Lightroom Catalog Previews.lrdata	322.3 MB
	Lightroom Catalog.lrcat	6.5 MB
Medium Catalog	Lightroom-2 Previews.lrdata	627.7 MB
	Lightroom-2.lrcat	197 MB
Large Catalog	Lightroom-3 Previews.lrdata	26.95 GB
	Lightroom-3.lrcat	171 MB

Depending on your shooting patterns, I recommend that you set Lightroom to backup this .lrcat file every time Lightroom opens, you may choose to skip that step, but once a week is probably a sensible timeframe. This is achieved by going to Catalog Settings (Command Option ,) and choosing from the options.

As you use Lightroom more and more, you will assemble a fair number of backup catalogs, these can be deleted over time, but it is worth keeping one or two of the most recent ones.

Fig. 2.8 The Catalog Setting dialog box. Here you find basic catalog information as well as choosing how often to back up the Catalog. The final option is to **Relaunch and Optimize**.

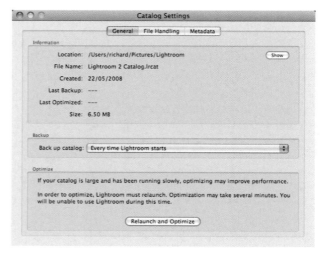

Fig. 2.9 Over time Catalog Backups will accumulate. It is safe to assume that most of the ones shown can be deleted. The whole folder takes up nearly 2.5 GB of disk space.

I also take the precaution of creating a Catalog backup before a large import or before a big Metadata update, just in case anything should go wrong. I have only had one Catalog issue throughout using betas, public betas and releases and that was

related to upgrading a catalog that was created with an old public beta, but it is always worth being cautious. Your images are your livelihood, so why risk anything!

If you perform a large amount of editing or deletion to your Catalog the occasional Catalog optimization is worth doing as well. I tend to perform a Catalog backup before an Optimization, again just in case! Optimization is Lightroom's equivalent of a 'vacuum'

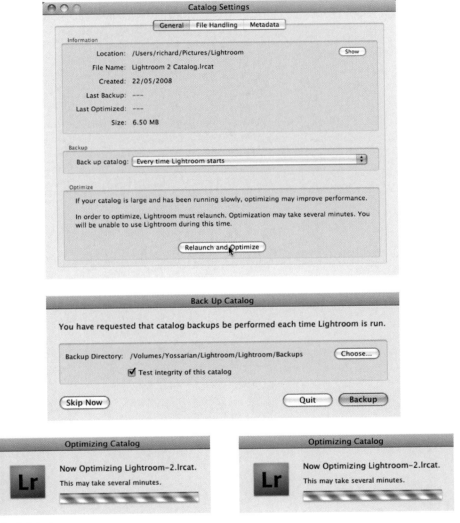

Fig. 2.10 Catalog Optimization.

RAID

RAID stands for Redundant Array of Inexpensive/Independent Disks. It is a method of utilizing two or more hard disk drives to achieve either greater speed, reliability or larger volume size.

There are several levels of RAID, each of which has its uses, but some are better for archival and some are better for speed.

RAID 0: Striped set, without parity. The disks appear as one volume. Fast, but if one of the disks fail all the data is lost. Capacity is virtually the sum of the disk sizes used.

RAID 1: Mirrored set, without parity. One disk mirrors the other. Good for archival, but if a disk fails, some data loss may occur. Capacity is equivalent to one of the disks.

RAID 5: Striped set, with parity. Needs a minimum of 3 disks, one is used as a parity controller for the others. If one disk is lost the parity disk can rebuild the RAID set. Capacity is the sum of the two other disks.

For more information visit: **http://tinyurl.com/686ck**

of the SQLite database. If you have performed a large number of deletions you will probably see the database size shrink by a bit. If you haven't done any, then the process will be less effective.

Testing your Catalog's integrity is also worth doing, any problems will be reported, for example you may find images that have become corrupted; testing the integrity can warn you of problems.

Backup

Also important, but easily overlooked in the heat of editing your images is the need to keep backup copies of your image library and your Lightroom Catalogs on other hard drives, as well as in an archive. For that you either need extra internal drives or external storage. There is a good range of internal storage available from Seagate, Western Digital, and Hitachi for external storage, I recommend using fast, capacious drives (7200 rpm at a minimum and preferably drives with a 16 MB cache, or larger). For good performance, I prefer to use Firewire 800 or eSATA connections for external Hard Drives, these will offer excellent speed. Firewire 400 and USB 2.0 are acceptable (Firewire 400 being slightly faster, as it is an asynchronous connection unlike the serial connection of USB 2.0) but they are not so fast when you are dealing with large quantities of images.

Archiving

For archival purposes, I recommend single unit hard drives, such as the LaCie d2, WesternDigital MyBook or Seagate FreeAgent brands, rather than some of the other LaCie drives (such as the Big Disk Extreme) which are multiple disk packages setup to be a RAID 0 (i.e.: they appear as one striped volume). They are fast and capacious, but if one of the disks goes then all your data will be lost.

Fig. 2.11 A LaCie Quadra d2, a Western Digital MyBook and a Seagate Free Agent. All images courtesy of the respective companies.

For archival purposes, single disks or RAID 1 setups are safer. RAID 5 is safer still as it uses at a minimum 3 disks with one used for 'parity'. A RAID 1 is safer than RAID 0, but if one disk goes you can still lose all your images.

However, my preference is still for single disks with automated backups, as I will explain later.

Network Disks are a good idea for archival backup, but less so for day to day use as they will be a bit slower. Also it is not recommended to use the main Lightroom Catalog on a network storage device. For archival purposes they will be fine.

Another sort of disk setup to think about is the relatively new Drobo from Data Robotics. It is a fully automated 'robot' backup solution and has gained a good following in recent months.

Fig. 2.12 A LaCie Ethernet Disk. Image courtesy of LaCie Inc.

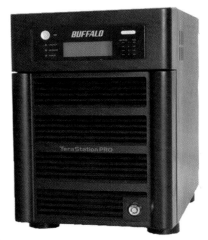

Fig. 2.13 A Buffalo TeraStation Pro™ II Network Attached Storage device. Image courtesy of Buffalo Inc.

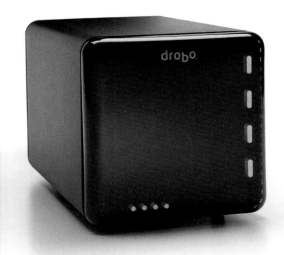

Fig. 2.14 A Drobo. Image courtesy of Data Robotics.

Synchronization

Chronosync for the Macintosh is available from Econ Technologies and allows you to schedule synchronization, which can be in the form or backups or bi-directional synchronizations. http://tinyurl.com/36yy9

There are other applications that can do a similar job, such as SuperDuper, RsyncX, Deja Vu.

For Windows, Microsoft offers **SyncToy,** but a closer equivalent to Chronosync is **Vice Versa**. http://tinyurl.com/rcow2

Again it is great for an archive system. The latest version, a recent upgrade, now supports Firewire 800 which makes it a more interesting prospect as a main drive system. The first time you do a backup it will be a slow process, but after that the automated backup routines will probably not get in the way.

A possible Disk Setup

The system I prefer, until something like a network disk gets improved connectivity, is multiple single disks. On my main production box, a MacPro, I have 4 internal hard drives and several external disks. My Library resides on one internal hard drive (a 1 TB SATA-300 drive), my catalog on another (a 750 GB SATA-300 drive). Both of these are backed up every night onto one of the internal drives and one of the external drives. This multiple backup solution is achieved on the Mac using ChronoSync from Econ Technologies. This allows for scheduled backups and synchronizations to take place. I tend to synchronize in the early hours of the morning, every day, so at the most I would lose 24 hours worth of images. However, I would fire off manual backups after a big shoot. ChronoSync allows a scheduled backup to be started at any time without messing up the schedule. If any of the disks fail, there will be a replica somewhere in the chain, which will allow for a speedy rebuild.

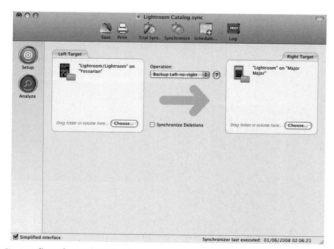
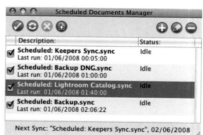
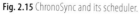

Fig. 2.15 ChronoSync and its scheduler.

External Disk A
Lightroom 2 Catalog Previews.lrdata
Lightroom 2 Catalog.lrcat
Image Library

External Disk B
Lightroom 2 Catalog Previews.lrdata
Lightroom 2 Catalog.lrcat
Image Library

Internal Hard Drive 1
Contains :
Lightroom 2 Catalog Previews.lrdata
Lightroom 2 Catalog.lrcat

Internal Hard Drive 2
Contains :
Image Library

Backup Regime
Nightly
External Disk A: at 00:30
External Disk B: at 01:00
or Manually at any point

Fig. 2.16 My back up regime. Images courtesy Apple and LaCie Inc.

I also have the option of taking one of the disks offline and replacing it with another. The offline volume could be rotated on a weekly basis and stored in another location.

Beyond that, regular backups onto Archival Media such as DVD and now Blu-ray are sensible. However, I recommend regular checking of the media and again, more than one DVD/Blu-ray Disc written of each session.

So hopefully you are now filled with terror and paranoia and are immediately thinking of a comprehensive backup strategy. If so, I have done a good job!

Monitors

The final aspect of your ideal system for Lightroom is the viewing device. There is a huge range of monitors to choose from that make ideal companions to Lightroom. Generally these days CRT monitors are unlikely to be purchased, instead flat screen monitors have become the norm. Newer technologies being used such as LED, which allows a brighter monitor to run on less power. The gamut of some of the monitors is larger than ever, with some being able to display close to the full gamut of AdobeRGB.

Fig. 2.17 A Blu-ray Disc.

Fig. 2.18 Eizo ColorEdge monitors with Calibration device.

Makes such as Eizo, NEC, Apple all produce high quality monitors which are ideal for use with Lightroom. And now with the new dual window feature in Lightroom 2, it makes even more sense to use 2 monitors. I would recommend getting two of the same; with most average monitors they might not produce the same results when viewing the same image. The tolerances on higher end monitors are much finer, but then the price is also much higher!

Calibration

One thing that is essential is to calibrate your monitor. This process matches the monitor to a known set of color values, allowing a range of monitors to produce consistent results.

Both Macintosh and Windows operating systems offer an in-built facility to produce a 'calibration' of your monitor but they are best avoided, as they rely entirely on the human eye to provide a calibration. Very few human eyes are that accurate and it is almost impossible to be sure that what you think is right really is!

Various companies produce color matching devices. Some are aimed at displays, other more advanced solutions can calibrate printers, projectors, scanners and digital cameras.

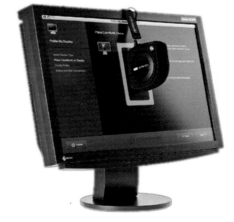
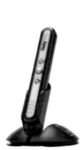

Fig. 2.19 The Pantone Huey Pro and the ColorMunki. *Images courtesy of Pantone, Inc and X-Rite, Inc.*

Some basic tools can be bought at a reasonable price and they will all do a pretty good job of accurately profiling your monitor.

At the lower end of the scale come products such as the Pantone Huey Pro and the new ColorMunki. The ColorMunki promises more than just display calibration as it can create printer profiles as well. They will certainly both produce an acceptable profile.

The generally accepted standard products in this field are the Spyder3 from Datacolor and the i1Display from X-Rite. They are very well established products that produce an excellent profile.

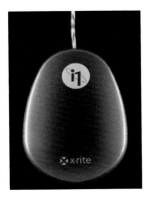

Once your monitor is profiled, and you will need to perform the calibration on a regular basis, you can have confidence that your monitor is producing accurate color in your images, so when it comes to making adjustments to images in Lightroom you are at least seeing what you should, rather than making judgements by guesswork.

This chapter will hopefully have given you an overview of a computer system that will be both powerful enough and stable enough to run Lightroom, with a view to making the most of your investment.

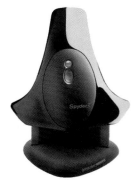

You can, of course, use lower powered computers, and Lightroom will run well, but as your digital image library grows and grows and you begin to do more and more in Lightroom, the extra power of the systems and components I have described will pay dividends in time saved.

Fig. 2.20 The i1Display and the Spyder3. *Images courtesy of X-Rite, Inc and Datacolor, AG.*

The aim of Lightroom is to enable the photographer to manage huge numbers of photos, this capability has to be matched with a system that enables you to do just that. Newer features such as Local Corrections will begin to tax a more basic system.

Now you have the best system, how do you deal with all that data. The next chapter, **File Management and Workflow** will look at the ways to do it.

What's New in 2?

The recently released Lightroom 2 is the first major upgrade to the application since 1.1. If you remember back that far, while Lightroom 1.0 was the first full release and 1.1 was a very major upgrade. Since then there have been more minor, but essential, upgrades including the odd new feature, bug fixes and support for new cameras to keep in line with Adobe Camera Raw releases. The final release of version 1 was 1.4.1.

Important to upgraders as well as new users is what are the new features. In this chapter we will go through these, sometimes explaining in detail and at other times there will be pointers to more explanation in context found in other chapters.

We will also have a look at some of the more requested features that haven't made it to 2.0 as they will have made their way higher up the priority list for future versions; be that a 2.1 or a 3.

Most of the new features in version 2 are to be found in the Library and Develop modules, however there are many global changes that affect all the modules, and there are some important features to be found in the Print module.

64 bit support and performance improvements

The first thing to note about Lightroom is that it is now a 64 bit application. This has major benefits for memory handling and throughput; Lightroom also has improvements in its ability to better use multiple processors and multi-core processors. Since multiple multi-core processors seem to be the way the main processor and computer manufacturers have decided is best for getting the most 'bang per buck', the improvements are very welcome.

In the chapter *The Ideal System*, we look at the ways to get or enable Lightroom for 64 bit. For Windows the installer will make an intelligent guess as to what you want, for the Mac you need to enable 64 bit support. Naturally you need to be running a 64 bit capable Operating System. That means either Windows Vista 64 bit, or Mac OS 10.5 Leopard. Note Windows XP 64 bit support is unofficial and not recommended!

If you run a 32 bit Operating System, provided you meet the minimum requirements, you will still be able to run Lightroom 2.

Fig. 3.1 Lightroom 2's splash screen showing it running in 64 bit mode.

Multiple-monitor Support

A feature that was hugely requested in version 1.0 was multiple monitor support. For many the lack of it was considered a 'deal breaker', especially when compared with Aperture or Photoshop. The main reasons for its non-appearance were that because of the design of the application it was slightly less essential than with other applications. I get the feeling that a lot of the developers and alpha testers of version 1 were laptop users so the need for dual monitors seemed less important to them.

The Lightroom developers provided ways to mitigate this deficit by allowing the hiding panels when they weren't needed, but for some that was not enough.

Lightroom 2 introduces multiple-monitor support and indeed multiple window support, as you are able to use the second window on your sole monitor if you wish.

Multiple-monitor support is enabled in the bottom left of the Lightroom screen, via the **Window > Secondary Display** menu or by pressing **Cmd F11**. If you hold down the Monitor icons you are given options of how you want to configure the setup.

Fig. 3.2 Activating Multiple-monitors via the icons. Holding down on the icons offers options.

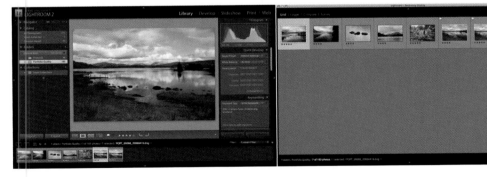

The two displays can be setup in a variety of ways. In the Figure above we see the Loupe on the left and the Grid on the right. Some of the other combinations are shown below, they are mostly combinations of the different views available in the Library Module; Grid, Loupe, Compare and Survey. You can only have one Grid view showing at a time on one of the Monitors. The default is to show a Grid view on one monitor and a Loupe in the other.

In the Loupe view on the second monitor, you have the three options, Normal, Live and Locked. Normal shows the image that you have selected either in the Grid or the Filmstrip, it can be resized as the behavior works on the main window.

In Live Loupe mode, as you roll over images in the Grid view, the image that your mouse is under is shown. This can be really useful for quickly cycling through a large batch of images, for rating, checking focus, or rejecting.

Locked Loupe keeps the image selected on the second monitor regardless of your selections on the primary monitor. Most useful for comparing one image with another.

The second window is visible in all the other modules. In version 1 you could only activate it in the Slideshow, but this is now application wide.

Productivity is certainly improved with this feature. It is not quite as flexible as the support found in Apple's Aperture, but it is certainly a step forward, should you have dual monitor setup.

Fig. 3.3 Some examples of the dual monitor setup in the Library Module.

1) Grid and Loupe
2) Grid and Compare
3) Grid and Survey
4) Loupe and Grid.

(1)

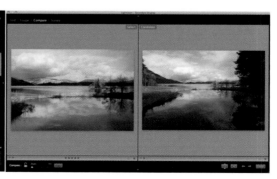

(2)

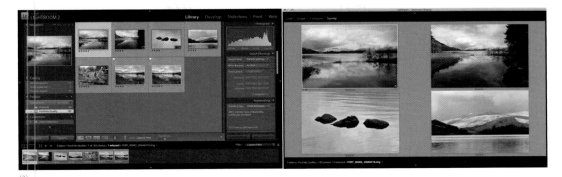

(3)

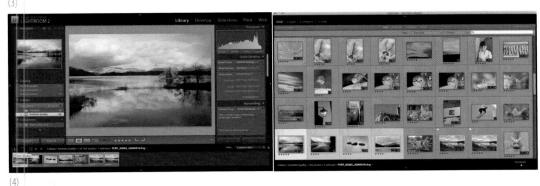

(4)

One way to use it in the Develop Module, is shown below. Here I
have hidden the left panel and the Filmstrip in the main window,
and in the secondary window, I have set it to be in the Loupe
view. I have then set Before and After view [\], applied some
Saturation and negative Vibrance. This way I can get a larger view
of both states. As you might imagine, this really comes into its
own on a setup with dual 30" monitors!

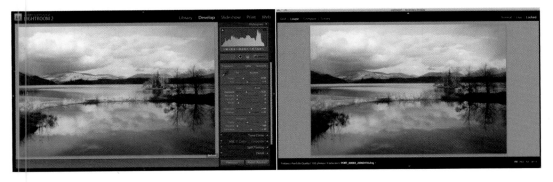

Adobe Camera Raw

ACR was first created as a stand-alone Plug-in for Photoshop, but was incorporated into the next release of Photoshop. It was Thomas Knoll's response to his frustration with existing Raw conversion software. Each version has added more and more features. The basic pipeline is used as the processing engine for Lightroom as well, so versions of the two tend to be released in sync and for optimum compatibility ACR should be updated at the same time as a Lightroom update comes out.

More information and the down-load page can be found at: http://tinyurl.com/640q

File Size

Another criticism of Lightroom 1 was that the maximum file dimension was only 10 000 pixels on the longest length. This proved very restrictive for those who shoot panoramas or want to combine images to make panoramas. It was originally a restriction imposed by Adobe Camera Raw, but has now been lifted.

Lightroom 2 boosts this to 65 000 pixels, although some file formats may not support files that large.

Integration with Photoshop

Lightroom 1 included some Photoshop support, for roundtripping images that needed Photoshop exclusive features. Lightroom 2 adds a range of extra functionality.

As before images that you send to Photoshop, will be added to the Lightroom Catalog, then sent to Photoshop for you to continue working. When you have finished and saved changes, the image will be updated in the Lightroom Library.

You now have extra options. Select several images in Lightroom and you can open them as a single multi-layer image in Photoshop, merge them to an HDR file or a Panorama. As well as all that you can now open a file as a Smart Object in Photoshop. To accomplish this you will need to have upgraded your version of Adobe Camera Raw to 4.5, which is the compatible version with Lightroom 2.

Fig. 3.4 Three images selected in Lightroom, ready for Merging to an HDR image.

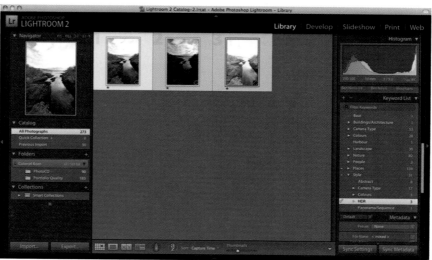

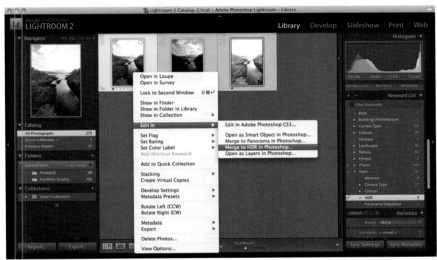

Fig. 3.5 Right-click to select Edit In > Merge to HDR in Photoshop. . . .

Here we have selected 3 images to Merge to HDR. Right-click to bring up the Edit In > Merge to HDR in Photoshop contextual menu. You will then receive a warning to check you have version 4.5 or greater of Adobe Camera Raw in place.

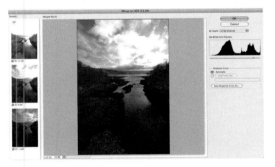

Fig. 3.6 In Photoshop you can select the sources of the HDR image, the method of conversion into a 16 bit image and then on saving it will appear in Lightroom.

Then go through the process for making an HDR image in Photoshop, and after you have saved your file it reappears in the Catalog as a Photoshop edited file.

Similarly, the Merge to Panorama is very useful for the creation of panoramas using Photoshop's increasingly sophisticated tool. The example shown below wouldn't have been possible in Lightroom 1 as at 12 573 pixels wide it was too large to be supported.

Fig. 3.7 Stepping through the Merge to Panorama in Photoshop. . . option.

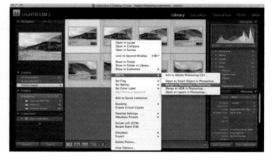

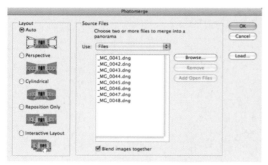
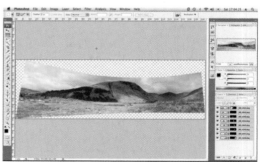

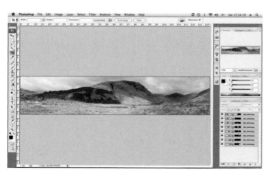
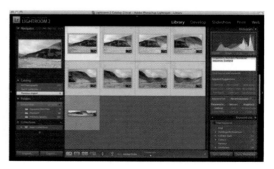

Collections in Lightroom 2

These allow you to create collections with settings for the three output modules, Slideshow, Print and Web. Because your settings are retained, any images you add to this Collection will automatically take on those settings. This is highly useful for photographers who need to create repeatable output packages, such as Wedding and Portrait photographers.

Collections

Collections in Lightroom 1 were useful but were a bit underpowered, now in version 2 they have a real purpose.

Collection Sets are the containers for collections, they are like a box to put them in and don't really do much more. You can't put images into them, only other Collections. In the example below, We have created a Collection Set called Black and White which contains a Collection of Black and White images as well as a separate Collection of Split-toned images.

Fig. 3.8 Collections and Collection Sets.

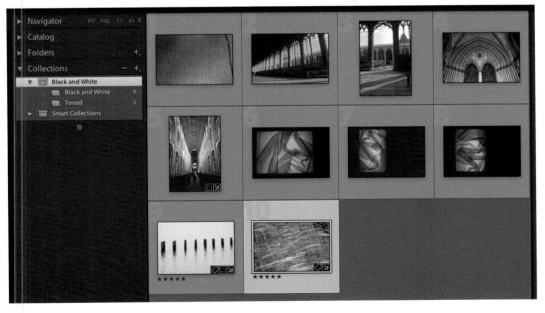

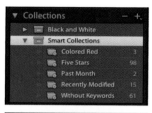

Fig. 3.9 Above: Smart Collections. Below: The criteria for a Smart Collection.

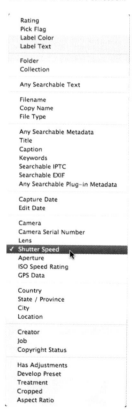

We could also add a Smart Collection, which is the third new form of Collection. Smart Collections allow you to create Collections based on seach and Metadata criteria. The basic ones supplied with Lightroom demonstrate some of their capabilities. We can find all images shot in the last month or those without Keywords. The advantage of Smart Collections is that they are dynamic, so as you add images without Keywords the Smart Collection will get updated on the fly. In the example, we can see the number of images without Keywords is 61. If I now select that Collection and add some Keywords to the images, this number will begin to fall.

To create a Smart Collection, go to the Collections pane, click the + button and select Create Smart Collection. ... You will then get a dialog box which allows you to add your criteria. In the example, I have created a Smart Collection called **Possible Noise**. My criteria includes looking for images with an ISO Rating of over 400 and a Shutter Speed slower than 1/60th sec. When we are satisfied with the terms, press **Create**.

As shown, the number of images in this Catalog that meet the criteria is 28. Any newly imported images with similar criteria will be added to the collection. As you can see from the figures below there is a large number of possible criteria and boolean options.

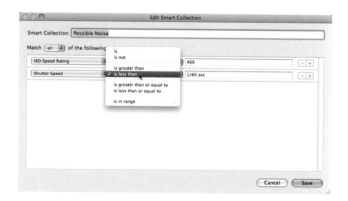

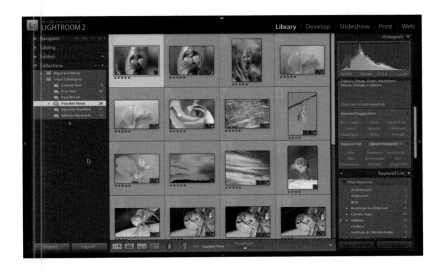

New Library Features

A lot of work has been done to refine the Library experience since version 1. There are still some inconsistencies to be found and no doubt it will be a work in progress for many upgrades to come.

The Volume Browser is found in the Folders pane. It offers the photographer a visual representation of the status of their disks. You can choose to view the available Disk Space, Photo Count, Status of the Volume or nothing. A warning light system is also used to show how much space is left on the disk. There are 4 statuses to note:

Color	Status	Space
Green	Connected	OK
Yellow/Orange	Connected	Getting Low/Lower
Red	Connected	Out of Space
Transparent	Disconnected	

Right-clicking on the disk name brings up the options, and the disclosure arrow on the right will hide the contents of the disk.

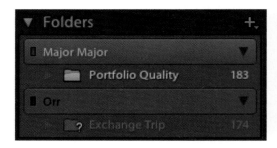
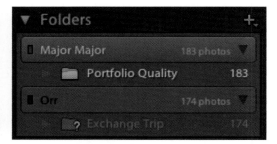

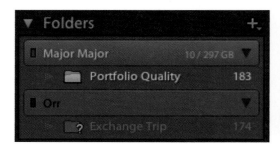
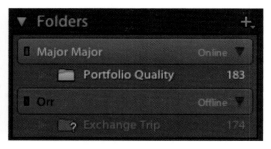

Fig. 3.10 Lightroom's Volume Browser statuses:
Top Row: Green , Yellow and Red
Middle Row: An online volume with an offline volume. Showing the number of photos on the disks.
Bottom Row: Disk space on online volume. Online or Offline status of volume.

Library Browsing

The previous Library find and browse facilities were relatively limited but version 2 has beefed these up and also repositioned them. It is now found at the top of the Grid view and if not visible can be activated with the `\´ key and is now called the Library Filter. It has several modes, Text, Attribute, Metadata, one or all of them and None. You can also create Custom Filters (Presets) to allow you to save often used criteria.

In the Text Search you are given pull-down menus and a text entry field to create searches. When you search by Attribute you are filtering based on Flag, Rating, Color and whether the photo is a Master or a Virtual Copy. In Metadata Search, you are able to narrow the criteria selecting items in a browsing pane. Each header can be set to one of the following criteria: Date, FileType, Keyword, Label, Camera, Camera Serial Number, Lens, Flash State,

Fig. 3.11 The Library Filter, showing Text Search, Attribute Search, and the Attribute and Metadata Search.

Shutter Speed, Aperture, ISO Speed, GPS Data, Location, City, State/Province, Country, Creator, Copyright Status, Job, Aspect Ratio, Treatment, Develop Preset, None and even whether you have uploaded a file using a Plug-in.

You can add or remove columns, view hierarchically or flat as well as sort them.

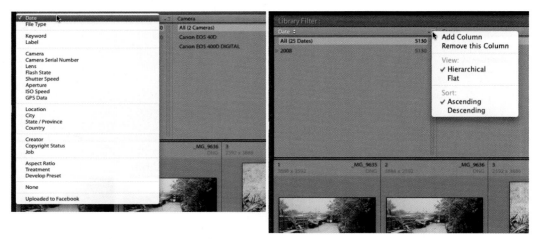

Fig. 3.12 Metadata Library filter criteria, and column preferences.

In the example below, I have searched for files taken in April, on a Canon 40D, with a Canon 100mm Macro Lens at a shutter speed of 1/100th sec. This has resulted in 7 images being found.

I can now save this as a new preset, for reuse, if this is a commonly used search. Adobe have provided some presets for this section and all of the Library filters can make use of the ability to save Presets. For more on Presets see the Lightroom Presets chapter.

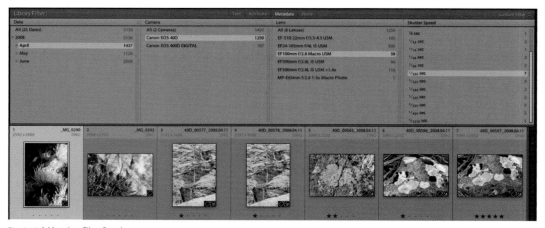

Fig. 3.13 A Metadata Filter Search.

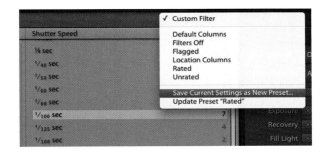

Fig. 3.14 Saving a Library Filter Preset.

A sign that Lightroom's interface is in a bit of flux is that some of this functionality is duplicated in the Filmstrip with the Filter Bar. You can use the same functionality as the Attributes filter and select, create and manage Library Filter Presets.

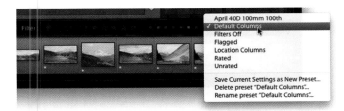

Fig. 3.15 Filter Bar.

Keywording

Version 2 has seen a reworking of the Keywording functionality as well. In version 1 the Keyword pane was part of the left panel, it has now been moved to the right panel. This means that the left panel in the Library module has a more logical grouping of panes in them, to do with Catalog information and management. The right panel now deals with how to change that information. Previously Keywording was divided into both panels, now the functionality is clumped together.

The first pane is Keywording and the first part of it is little changed from version 1. You can still enter Keywords here, and select whether the panel's functionality should be `**Enter Keywords´, `Keywords & Containing Tags´** and whether they `**Will Export´**. If you choose Enter Keywords then, as before, you can Add keywords to images of batches of images. If you choose either of the other two functions then you have to use the new `**Click here to add keywords´** box.

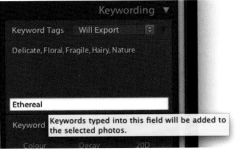

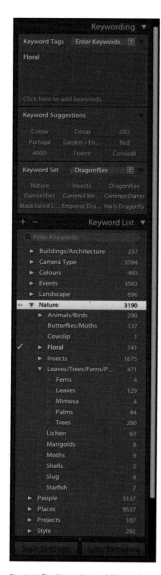

Fig. 3.16 The Kewording and Keyword List panes.

Lightroom 2 now offers **Keyword Suggestions**. These are based on entries of photos whose capture times are in close proximity. Applying the suggestions is simply a matter of clicking the box containing the Keyword you wish to apply. Below we have selected `Red´.

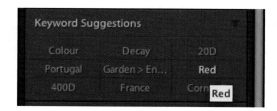

Keyword Set is not new to version 2, and neither is the ability to save Presets, so it is not covered here, but is in the chapter on Lightroom Presets.

The Keyword List pane has had a revamp for Lightroom 2, a Filter Keywords dialog box is at the top and this is used to narrow down the Keyword List.

Entering a Keyword or part of a Keyword will immediately start narrowing down the visible Keywords in the Keyword List. However, if you have nested Keywords you will still be able to see the hierarchy. In the example below, I have searched for the Keyword `Nettles´ and it shows me I have that Keyword in the hierarchy **Nature** > **Floral** > **Nettles**.

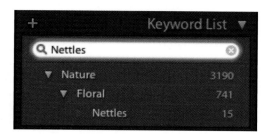

Fig. 3.17 Entering a Keyword Filter.

If I had multiple Keywords `Nettles´ I would see the different hierarchies.

Performing this Keyword filter doesn't filter the images, just the Keyword List. To do this, you can use another new feature in 2.0 and that is the Keyword filter arrow.

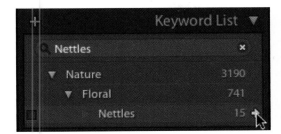

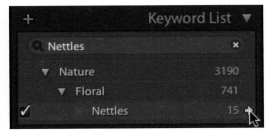

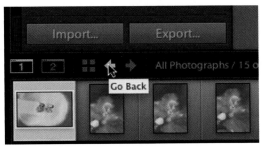

Click this arrow to filter the images based on the Keyword. Unfortunately to remove this filter you have to mouse over to the other side of the screen and press the **Go Back** arrow! It might be more useful for the arrow to have a toggle function.

Fig. 3.18 Applying a Keyword Image Filter. To undo hit the Go Back arrow.

Exporting

Export has had a slight revamp, continuing its interface redesign from version 1.4. New features include the ability to save exports into the same folder or subfolder or the original location; add the exported images to the Lightroom Catalog – with the option to stack them with the original image; sharpen on export, for Screen and Print – with Print you are offered Matte or Gloss paper as options; and send exported images directly to a third part application – previously you would have to export to a folder, then they would get added to the chosen application.

You can also manage Plug-ins from the Export dialog box. If you frequently use them then this will be a big timesaver.

From the Plug-in Manager you also have a link to the Lightroom Exchange. This was introduced during the Public Beta of 2.0 and is a repository for Presets, Galleries and Plug-ins.

That wraps up the changes in the Library Module and there have been some very useful additions and some thoughtful touches added in this release. As I mentioned earlier in the chapter this will always be a work in progress part of Lightroom and I wouldn't be surprised to see many more changes to this area in future versions.

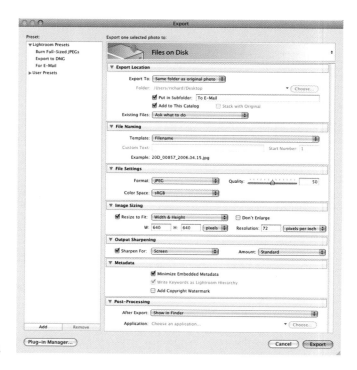

Fig. 3.19 The Export dialog box.

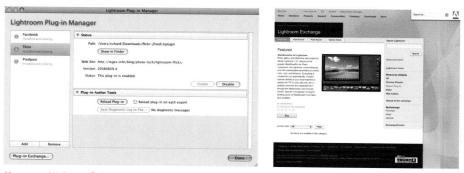

Fig. 3.20 The Plug-in Manager and Lightroom Exchange.

Develop Module Changes

There are also several big changes to the Develop Module to look at, containing, perhaps the biggest additions to the feature set.

The interface to the Develop Module has undergone some subtle changes, perhaps not as radical-looking as the Library until you see the addition of some new tools! Mostly the module looks familiar, the only noticeable change to the left panels is the new icon system for Presets. The bottom Toolbar has lost some of the tools as they have been repositioned below the Histogram.

The right hand panel, however, contains new Develop features.

The first thing to mention is that the RGB readouts are now at the bottom of the Histogram pane. This is a much more logical place

for them as you are more likely to need to know these numbers in proximity to the Histogram. Before they were in the bottom Toolbar which was visually far too far away.

Skipping the Tool Shelf for the moment, the Basic Panel has a couple of notable changes. The Auto Tone feature now has improved algorithms and so should produce better looking corrections. In version 1 the Auto Tone adjustment often

Fig. 3.21 New icons in the Presets pane, and the slimmed down Toolbar.

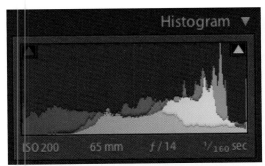

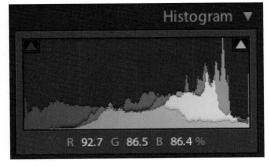

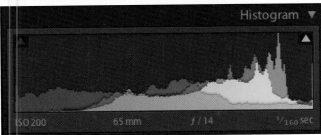

Fig. 3.22 The Histogram tool. RGB Readouts as you mouseover the image. Maximising the width of the Histogram.

I want my old 0–255 scale back!

This has probably been one of the loudest cries of distress from Lightroom users since its original launch. They are not there for a good reason – not just to spite users!

In the high bit-depth world of Lightroom and Raw processing 0–255 numbers make no sense whatsoever as they refer to an 8 bit scale. Lightroom works in such high bit-depth, in comparison that using the 'old' numbers would lead to quite big errors.

Better to get used to percentage readouts than hanker for something that is unlikely to return!

produced overly bright results. In the two examples below, the left-hand image was produced in Lightroom 1.4.1 and the right-hand image was produced in Lightroom 2. There is a small amount of difference, whereas in the Lightroom 1 version the Brightness is set to +66 and the Contrast to +32, in version 2 Brightness is +53 and Contrast is +42.

Fig. 3.23 Auto Tone in Lightroom 1.4.1 and 2.0 respectively.

The other new feature is Negative Clarity. Before the Clarity scale was from 0–100, now the scale is from −100 to +100. Perhaps most useful on retouching models, where it will prove invaluable to soften wrinkles and pores. When used with Sharpening it can

Fig. 3.24 From left to right:
1) Original Image.
2) Clarity +100.
3) Clarity −100.
4) Clarity −60; Vibrance −8; Sharpen Amount +47.

prove an effective tool. As it is a global correction it might prove to be too much for some images and will probably be better used with a Localized Correction.

There are no changes to the rest of the Basic Tools, the Tone Curve and the HSL/Color/Grayscale panes. The Split Toning pane does receive a slight interface enhancement with an integrated color picker in the pane with version 2, as shown below.

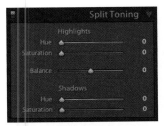 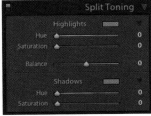

Fig. 3.25 Clockwise from top left:
1) Split Toning v 1.0.
2) Split Toning v 2.0.
3) Pop up Color Picker in v 2.0.

Detail

The Detail pane also gets a makeover. Instead of the button in version 1 to enlarge the image to 1:1 so that you could see the sharpening effects, there is now a Detail window, with a variation of a Targeted Adjustment Tool. Use the tool to select the area of the image you wish to view as you make Detail adjustments and they will be reflected in the window.

Chromatic Aberration adjustments are now to be found in this pane, as a logical consolidation of Detail tools. There is also a reordering of the items in the pane with Sharpening coming before Noise Reduction.

Vignettes

The Vignettes pane now includes a Post-Crop Vignette feature. In version 1, Vignettes only worked on the full image, if you

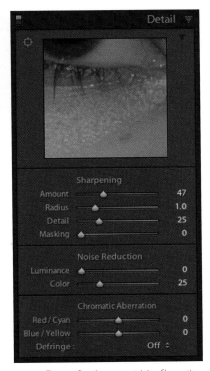

Fig. 3.26 The new Detail pane, containing Chromatic Aberration and the Detail window.

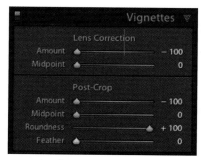

Fig. 3.27 Lens Correction Vignettes, now coupled with Post-Crop Vignettes.

cropped the image, you wouldn't see the vignette applied. This method is still retained and renamed Lens Correction. The Post-Crop has further features to adjust the Roundness and Feather of the Vignette. You can also combine a Lens Correction Vignette with a Post-Crop Vignette for more dramatic effect.

Trying various settings as seen overleaf can result in fisheye effects, soft borders, and rounded edges. You will be able to find some Presets of these Vignette effects at the Inside Lightroom website. **http://tinyurl.com/5n6nw3**.

Camera Calibration

The fundamentals of this panel have not changed since version 1. Its aim is to allow both techincal and creative control over the way colors are rendered in Lightroom (and Adobe Camera Raw too). The technical method is to allow you to 'calibrate' your camera to compensate for any unit variations from the one that was profiled by Adobe.

When Adobe profiles a camera, it uses two built-in profiles. The first is created under D65 lighting, the second under 3200K Tungsten. This can be seen in the Color Temperature slider in the Basic Panel; adjusting the slider will use these profiles to interpolate what is happening at the temperature you have selected. This is quite different from other software such as Capture One which allows the use of Custom Profiles. The advantage of Adobe's method is that you can generally set your camera to Auto White Balance and let this slider do the work. For studio shooters who need more accuracy there is the Camera Calibration panel.

Camera Calibration

The late Bruce Fraser first explained the process of using the Camera Calibration facility on the Creative Pro website: **http://tinyurl.com/5cex9q**. Automation scripts are available to make this a slightly less laborious process. Three such scripts are available from the following links:

Chromoholics: **http://tinyurl.com/5lss2e**

Rags Gardner: **http://tinyurl.com/7s2xf**

Simon Tindemans: **http://tinyurl.com/569jah**

As mentioned, unit-to-unit variation is possible with models of cameras, although they rarely vary by huge amounts. To compensate for this it is possible to compare your camera's rendering of a known target and enter these values in the Camera Calibration window.

This process can be done manually as first described by the late Bruce Fraser. Since he wrote that several scripts have appeared to automate the process.

Essentially, you shoot a Macbeth Color Checker and the script compares the rendering your camera makes with what the values should be. This has to be done in Adobe Camera Raw rather than Lightroom.

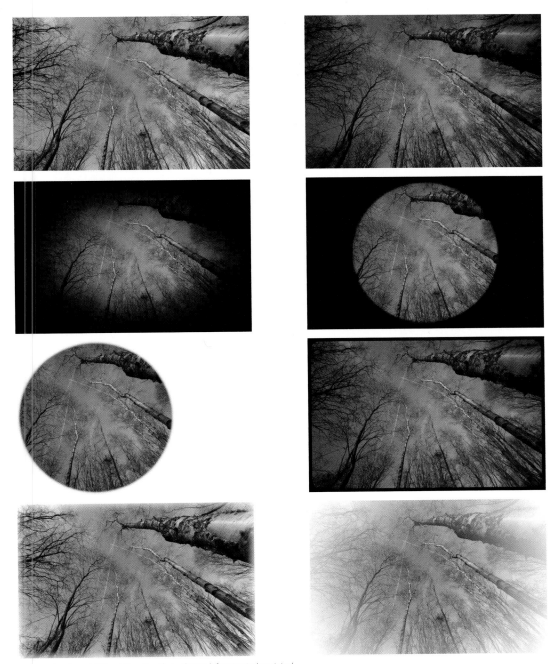

Fig. 3.28 A variety of different Vignette effects. The top left image is the original.

Fig. 3.29 Top Left: Original
Top Right: Lens Correction Vignette applied,
producing darkened edges.
Bottom Left: Image cropped, Lens Correction
Vignette not visible.
Bottom Right: Post-Crop Vignette applied.

Fig. 3.30 The extremes of the Color Temperature slider;
left: 2000K; right: 50 000K

Once you have followed the procedures and you are happy with the results, you should then save this Calibration as a Preset. Then it can be easily applied to a batch of images or on import. For more information on that process see the chapter on Presets.

What has confused a number of people about the Camera Calibration is the area of profile versions. When a new camera is released, Adobe creates a profile for it which is then made public with a version of Camera Raw (and/or Lightroom). The Profile will take the name of the ACR release number. Confusion arises when the user next updates their version of Camera Raw, yet the version of the profile has not updated. This number is simply tied to the version when it was created.

Sometimes, as happened with Adobe Camera Raw 4.4, all profiles get updated. This can happen when a revised method of profiling happens. In 4.4 the profiles created worked better for some very low color temperatures/high tint combinations.

This means that most images from cameras that were released prior to ACR 4.4, will see two or more profiles in the pop-up menu.

The Canon EOS 40D has ACR 4.2 and ACR 4.4. The Canon EOS 20D will show ACR 2.4 and 4.4. You can then 'update' the profile to the new 4.4, which should result in an improved rendering of your image.

Camera Raw 4.5 (which is the version incorporated into Lightroom 2) has extended the range of profiles that are available. The new profiles are intended to offer a greater variety of looks for an image, than the fairly neutral one provided by the Adobe defaults.

Many photographers prefer the looks that a camera applies to its JPEG files and via manufacturer's Raw software. For some they are too strong. In ACR 4.5 there are a range of new profiles supplied; .dcp files which live in the following places:

Mac: /Library/Application Support/Adobe/CameraRaw/ Camera Profiles
Windows XP: C:\Documents and Settings\<username>\ Application Data\Adobe\CameraRaw\Camera Profiles

There are profiles for all supported cameras provided, you will only see those relevant for your camera. Install the Profiles,

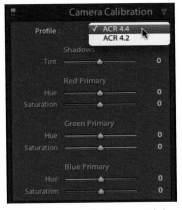

Fig. 3.31 The Camera Calibration pane, with the option to choose between the ACR 4.4 and the ACR 4.2 profile for a Canon EOS 40D image.

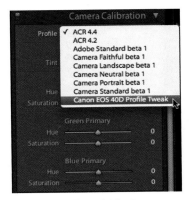

Fig. 3.32 New Profiles with ACR 4.5.

Fig. 3.33 The same image with the Faithful Profile (top) and the Landscape Profile (bottom).

restart Bridge, Photoshop or Lightroom. Now in the Camera Calibration pane you will see more options. In this case with the Canon EOS 40D you see, ACR 4.4, ACR 4.2, Adobe Standard beta 1, Camera Faithful beta1, Camera Landscape beta 1, Camera Neutral beta 1, Camera Portrait beta 1 and Camera Standard beta 1. Figure 3.33 shows the same image with the Faithful and the Landscape Profile.

DNG Profile Editor

Released with Adobe Camera 4.5, the DNG Profile Editor is the answer to many photographers' pleas. Some have criticized the inability to create individual looks for their cameras, or have found that the Camera Raw interpretation of color just doesn't work; this should be the solution. Released as a beta, it and the new Camera Profiles can be found at: **http://tinyurl.com/5nuhjk**.

With the Profile Editor you open a DNG file and can create your own profiles. You are able to create a look for a style of image, which can be shared across different cameras. Colors can be locked, which can be highly useful if you are trying to keep one color vibrant but perhaps reduce the vibrancy of another similar color. If you have a profile that is nearly right, but not quite, then the Profile Editor can use that profile as a base to 'improve' the look. You can also start with a Color Checker, and perform a calibration similar to the previously mentioned Javascripts.

Of course all this can be highly subjective; a photographer or a client will often react well to a 'pleasing' look of an image, but it may be very inaccurate when you look at the numbers. And the numbers view of the image might make it look dull or ugly even. But at least we now have the chance to go beyond the previous Adobe view of color if necessary.

The DNG Profile Editor starts with a DNG file. You can normalize the White Balance, select colors in the image and shift them to your preferred response, apply a Tone Curve, adjust the Primaries (similar to the Color Calibration section in Camera Raw and Lightroom) and then add information and protection policies to the Profiles.

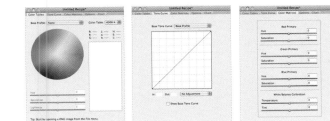

Fig. 3.34 The five main screens of the DNG Profile Editor: Color Tables, Tone Curve, Color Matrices, Options and Chart.

In the example below, I opened a Color Checker. The application requires me to move four color coded circles to the center of the four corner swatches, press **Create Color Table** and it will display the table based on the color temperature(s) you selected.

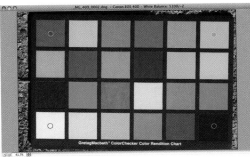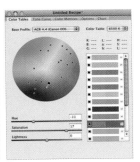

Fig. 3.35 Opening a Color Checker in the Profile Editor and building a Color Table.

Now you can make adjustmments to where the colors fall on the color wheel. Select one of the swatches in the right hand panel, it will be highlighted in the color wheel, with the arrow showing how different the swatch's response is to the target color. Adjusting the HSL in this instance will move the color closer to the target. From that point you can make further adjustments, save a color recipe and Export a Color Profile.

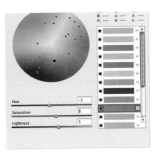

Fig. 3.36 Selecting a swatch (the color split shows the difference between the rendition and target color). The black square shows a before and after split. The Color Wheel shows the variance from the target color. Adjusting the HSL moves the color towards the target.

Fig. 3.37 The profile in Lightroom's Color Calibration Panel.

The newly created profile will need to be installed in the folders mentioned previously and then restart, Lightroom, Bridge or Photoshop. The new profile will be available in the Color Calibration panel.

The potential for this is huge and I'm sure we will see a good trade in new profiles, with some being created for special effects as well. This will also bring Camera Raw into line with some of its competitors such as Phase One's Capture One.

Lightroom's Tool Shelf

We now move on to the big new Develop Features which are located in the new Tool Shelf below the Histogram pane. This houses tools that were previously on the bottom Toolbar, **Crop Overlay**, **Spot Removal** and **Red Eye Correction**.

The two new tools are ones that have been much requested, **Graduated Filter** and **Adjustment Brush**. The former is akin to the sort of ND Grad filters you can fit to the front of your lens

Fig. 3.38 The Crop Overlay, Sport Removal and Red Eye Correction tools in their new home.

(although with extra options). The latter is Localized corrections. Both of these make a huge difference to the creative control you now have in Lightroom. All other corrections in the Develop Module are global, meaning that you have been unable to adjust sections of an image.

Graduated Filter

As mentioned this tool is similar to an ND Grad filter, but with a variety of extra effects. Firstly, you are able to have multiple gradients, which perform different actions. You can apply one or more Basic adjustments to the gradient. You can choose from Exposure, Brightness, Contrast, Saturations, Clarity, Sharpness and a Color overlay. You can also save and apply Presets. One such preset is Soften Skin, which changes Clarity to −100 and increases Sharpness to +25.

With the Graduated Filters you can build several masks and apply the appropriate effects to bring out the best in the image. You can control the depth and direction of the gradient. Here is a walkthough of an image from the inital import to the final version.

Ideally the initial exposure would have been better and the use of an ND Grad at shooting time would have obviated the need to apply this. But as that didn't happen it proved a useful post capture tool, allowing me to realize the initial vision.

Once you have created a Gradient, you can adjust its overall strength and update the strength of the individual settings.

Fig. 3.39 Top: Graduated Filter; bottom: Adjustment Brush.

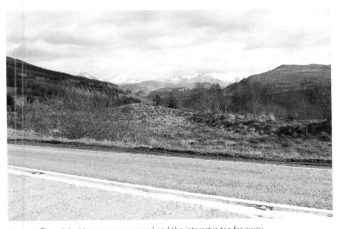

Fig. 3.40 The original image, over exposed and the interest is too far away.

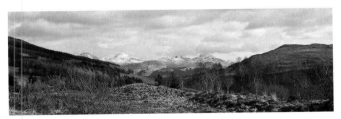

Fig. 3.41 The same image cropped, exposure adjustments and Clarity applied.

You can save Presets of your Gradient Filters, either for applying to many images or to provide a starting point for further effects. See the Presets chapter for more information. The Develop Workflow chapter will show more examples of it in use.

Fig. 3.42 The image with a Gradient applied to darken the sky, reduce the contrast and add some Clarity. The Gradient applied in Lightroom: drag the top and bottom lines to adjust the length of the gradient. The central line adjusts the angle.

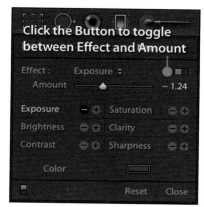

Fig. 3.43 Strength Adjustment.

Adjustment Brush

The Adjustment Brush provides full localized correction, with a powerful set of tools that will lessen the need for the photographer to render an image to Photoshop for this sort of correction. Selecting the **Adjustment Brush** tool (**K**) allows you to paint a mask to which you can apply similar corrections to those found in the Graduated Filter.

The additional tools are for choosing the **Size**, **Feather** and **Flow** of the brush. The **Auto Mask** checkbox offers edge protection when you are painting, so that your brush strokes won't bleed into areas you don't want. The **A** and **B** buttons remember two of your brush settings; so **A** might be a soft brush with a big feather

Fig. 3.44 The final image, with a second gradient applied, this time angled at the bottom of the image adding some Exposure, Saturation and Clarity.

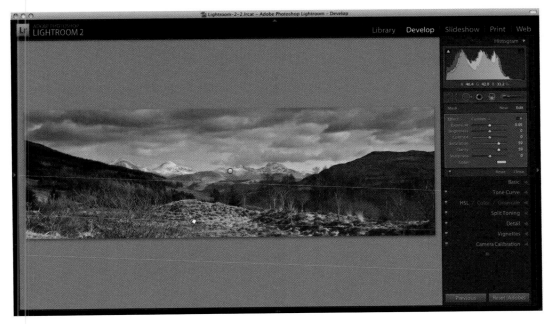

and **B** might be a harder, finer Brush. The **Erase** button offers an erase brush; this is also accomplished by pressing the **Option** key as you paint. Using this toggle is a great way to clean up edges where the Auto Mask hasn't been perfect.

In the following example (see Figure 3.45) the image was taken in harsh directional light with a flash. This has divided the image into two parts, one bright, one darker.

This is a multi-part retouch, so firstly I have removed some of the skin blemishes.

I have used the Adjustment Brush to paint a mask on the light area. The left image shows the mask as I am painting it – in this case I have set the exposure to be quite dark, so that I can see as I am

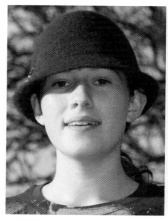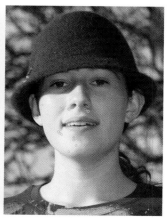

Fig 3.45 Using the Spot Removal tool.

painting. Pressing the **O** key will show the painting mask in red (like an old fashioned rubylith). Moving your mouse over the adjustment point will also temporarily show it in red (see Figure 3.46). Pressing **Shift O**, repeatedly will change the color of the mask. From red to green to white to nothing (see Figure 3.47). This is really useful if your image has colors that are too similar to the masks.

If you go over an edge as you are painting the mask, you can either use the Erase brush, or check the Auto Mask to protect the edges (see Figure 3.48). There may still be some parts of the image where edge detection is harder, so the Erase brush can be useful for those areas.

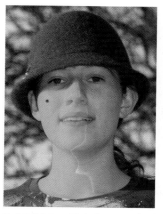

Fig 3.46 Painting with the Exposure reduced, so you see the mask you are creating. Press Shift O to see the mask in color.

Fig 3.47 Continue to press Shift O to see the mask in Green, White and back to nothing.

Finally, when you are happy that your mask is perfect, you can begin to use the Adjustment Tools, in this case to balance the image more.

Fig 3.48 Using Auto Mask to achieve a better edge.

With this image, I needed to lower the Exposure, Brightness and Contrast, and added a small amount of Clarity. I also made the Amount 64. This has provided a better balance to the image, and I could continue to make global adjustments if I wanted. In this case I altered the general Exposure, Recovery and Clarity.

These new adjustment tools offer a huge amount of control over your images. Best of all the changes are still achieved as metadata edits, so are non-destructive to the original image. This is unlike Apple's Aperture which has to render the image as a bitmap, before it can apply Dodge and Burn tools. Other software such as Nik Software's Viveza, can achieve similar effects, through their U Point® technology, which is vector-based rather than brush-based.

Fig 3.49 Before and After.

Slideshow

After all the new features found in the Develop Module, Slideshow has perhaps been slightly neglected in this version. Apart from the new ubiquitous Collections, there is one new feature, and that is the ability to Export your Slideshow to JPEG, previously this was restricted to exporting to Acrobat PDF. This will be most useful if you want to create Slideshows outside Lightroom. All of the visual effects are then baked in the JPEG files as can be seen in the examples.

Fig 3.50 Left: Lightroom 1 offered the ability to Export to PDF only. Right: Lightroom 2 allows you to Export to PDF and JPEG.

Fig 3.51 The Slideshow module and a Slideshow frame exported to a JPEG file.

Print

Lightroom 2's Print module has also undergone a revamp, some panels have been rationalized to offer a more logical separation of the layout functions. The main new features are revised Print Sharpening, the nearest thing to Soft Proofing which is Print to JPEG file,16 bit Output and, perhaps, biggest of all Picture Packages.

Revised Print Sharpening

Lightroom 1 included Print Sharpening, but most of the feedback was that it wasn't that good! Lightroom 2's Print Sharpening has been beefed up by input from Pixel Genius. They are the creators of PhotoKit Sharpener, which was the result of years of research by the late Bruce Fraser into sharpening technology and how it translated to output media. Since Bruce's death, the work has been continued by consultancy from Jeff Schewe, who worked closely with Bruce.

Fig 3.52 The new Print Sharpening dialog box.

Sharpening is still one of **Low**, **Standard** or **High**, but you can now choose whether your output media is **Glossy** or **Matte**. The algorithms are completely rewritten and will offer optimized print sharpening. During the Public Beta of Lightroom 2, there was some talk of further output choices, such as for print labs, but there was found to be no real difference between that and Glossy output. The main drawback with this is that unless you produce test prints you won't really see the benefits of the sharpening changes. You can use the new Print to JPEG feature, but viewing print sharpening on screen is counter-productive as the sharpening is likely to look pretty horrible, but will print perfectly.

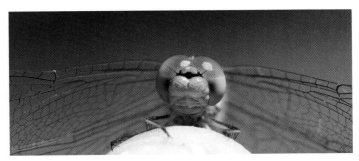

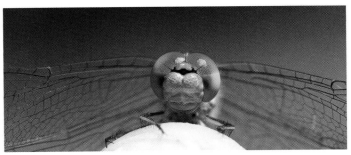

Fig 3.53 **Top**: No sharpening applied. **Bottom**: High Print Sharpening for Glossy Media.

The images in Figure 3.53, try to show this, although the effects may be diminished in print!

Print to JPEG

As mentioned above, the new Print to JPEG feature can be used to Soft Proof for printing. It is not quite as useful as a full Soft Proof feature, but can certainly substitute for it. However, you will have to mentally calculate what the difference between the image you see on screen and the printed output.

The Print to JPEG feature can also be used in a similar way to the Export to JPEG feature in the Slideshow module, as a method of exporting the layout settings you have applied in the Print module to a file, which could then be sent to a client.

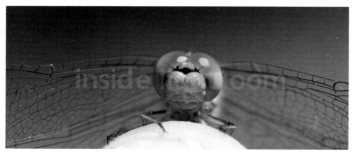

Fig 3.54 A watermark, created with Print to JPEG.

An example of this shown in Figure 3.54 allows you to add a watermark to your image. Using the Identity Plate as an Overlay, you can adjust size, position and opacity, although you would have to crop the image after the print to file!

16 bit output

Printing quality has been improved by the addition of 16 bit output. At the moment this is only supported on the Mac, as Windows XP and Vista do not have support for 16 bit Printing. Drivers have only been written for some of the newer Epson and Canon printers, and you will need to be running Mac OS X 10.5 (Leopard) to take advantage of this feature. Beauty images will probably show any differences in highlights and gradients and some images may show no difference at all. As printers continue to improve, 16 bit output will enable images to reproduce far more of the original subtleties.

Picture Packages

This replicates a Photoshop feature, and allows photographers to produce 'proof sheets' which can be used for marketing purposes.

You can produce multi-page layouts but they will always contain the same image. So as a feature it is a step in the direction of more complex layout tools, such as for books or photo albums, but it isn't there yet.

It is easy to add new package boxes using the buttons in the Cells panels. These are the standard sizes that Lightroom 2 offers, clicking the pulldown menu offers you the option to edit these sizes. There are fewer layout tools available, but for creating quick layouts the whole process is smooth and efficient.

And as you might guess, these layouts can be retained by saving a Template (Preset) and they can be printed to a color printer or printed to a file (as we have seen before).

Web

The Web Module has one minor new feature which is Sharpening and a minor change in the interface. The changes are simply the moving of the action buttons found at the bottom of the panels for interface consistency.

Fig 3.55 The Print Package interface with the Add to Package panel shown in detail.

Sharpening is Low, Standard and High and is based on the PhotoKit routines for output, as appears in other modules and in the Export module.

What is not in 2!

Predictably there were a few wails of despair when the Public Beta of Lightroom 2 appeared about features that were missing. This will probably always be a problem with Lightroom as it is

developed by a relatively small team who have very aggressive deadlines. In part they are having to keep in sync with Adobe Camera Raw features, and no doubt Adobe would not be too happy if every feature possible was put into one release!

Judging from the Public Beta of version 1 and the forums following the full release of version 1, the most requested features are incorporated, or if not may well be added to the list of possible features for the next version.

Just after the Public Beta of version 2 was released, Scott Kelby (fellow author, photographer and blogger) created a wishlist for Lightroom 2 **http://tinyurl.com/69ty9s**. This was a valuable list of possible features that could be incorporated into Lightroom and there were 319 comments on the post, most of which had more suggestions. In a response Tom Hogarty the Product Manager for Lightroom said that if Adobe tried to implemement all of the features it might take 5 years or 5 versions! **http://tinyurl.com/5ffywe**. He also made the points that they listen to feedback and that they were thinking along the same lines as the users, which can only be good news for Lightroom!

Below is a brief list of features that seem to be the most requested following the release of the Public Beta, that don't appear in the final release version. There is no guarantee that any of them will ever make it to the next or a future version, but I think we can be optimistic that Adobe will try to add some of these features as soon as it can.

Soft Proofing: The ablility to see on screen what a print is going to look like when printed is a very requested feature. Known as soft proofing and present in Photoshop, it would require a method of simulating the effect of a color profile on an image.

Perspective Correction and Lens Correction: At the moment, the only way to achieve this with Lightroom is to use Photoshop (or similar) as an external editor; editing as a Smart Object. The argument is that this should be internal to Lightroom, and I would imagine it is high up on the list of features to come.

Network Support: At the moment Lightroom can't work on a network – its database SQLite is meant for single machine use. For a photographer in a studio this might be a massive drawback.

Full DAM facilities: Many photographers have become firm fans of the methodology described by Peter Krogh, in *The DAM Book*, Lightroom only goes some of the way towards offering the

Fig 3.56 DxO is an example of a standalong Lens Correction application.

workflow recommended. Many photographers want Lightroom to go much further.

Archiving: Archiving is essential to all photographers, but Lightroom lacks the ability within the application to archive. The most you can achieve is exporting Catalogs or exporting files to archival media.

File Formats: CMYK files and other image formats that aren't supported should be, according to many photographers. It would also help fulfil Lightroom being a full DAM solution.

Improved Slideshows: As we saw earlier in the chapter, the Slideshow module lacked some love in the upgrade to Lightroom 2. Exporting to other presentation formats improved transitions are just two highly requested features and there is hope that more will be done in future upgrades.

Printing: The biggest desire in the Print Module to have the ability to create books (and similar projects). The growing popularity of on-demand printed books makes this a popular request, and whether it will be provided by Adobe, or a third party we can't be sure, but the addition of Print Packages in Lightroom 2 offers a glimmer of hope that the feature might appear in a future version.

Noise Reduction: Generally users want noise reduction that is on a par with Noise Ninja from Picture Code or Noiseware from Imagenomic. And because it is the 'Lightroom way' that would need to be achieved as a metadata edit.

This is not an exhaustive list, but gives some ideas as to the most talked about must-haves on the various Lightroom Forums. Knowing Adobe, they will try their best to add these, and will probably surprise us with something no one has thought of!

The Lightroom SDK

A new Lightroom SDK is available with version 2. It allows a developer to create Export plug-ins, customized metadata fields and web engine functionality. Some results from the SDK will probably be available within a few weeks of the new version being available.

In the future the hope is that the SDK will allow much more extensibility to Lightroom in the way that Photoshop does with its Plug-in extensibility.

As mentioned in other chapters, an understanding of Lua scripting will be of immense benefit.

Fig 3.57 Noise Ninja and Noiseware. Noise Reduction software.

Fig 3.58 The Lightroom 2 SDK.

File Management and Workflow

We have looked at creating the ideal platform on which to run Lightroom, now we need to look at how best to use it.

As we saw, Lightroom's aim is to let photographers manage the hundreds and thousands of photos that digital photographers are capable of generating in a very short period of time. Sports, Wedding and Fashion photography are the photographic disciplines that will come under that category. The needs of these photographers for fast editing and output are much greater than, for example, a Nature photographer. But even then a day's shoot can generate 400–500 images fairly easily, so all potential users of Lightroom will face the need to get their images off the card quickly and safely, store and archive the main shoot, import the images and begin to add Metadata and Develop their images.

Many photographers coming to Lightroom for the first time and even those who have used other software will have created a workflow that suits their needs. Maybe it is even based on workflows created in film days. But they may now find that using Lightroom in their old way is more awkward than they were led to believe. How best to manage your assets and structure your workflow is what concerns us in this chapter.

File Structure

In my view, it is essential to plan your file structure before you even open Lightroom. Lightroom is reasonably agnostic about where you store the images on your computer, but the benefits of doing so in the most efficient way will use all of Lightroom's capabilities and rationalize your workflow.

How you structure your images might well be dictated by the type of photographer you are. A Wedding Photographer, for example, may structure their image library by Wedding Name containing sub-directories named and organized by Bride, Groom, Best Man etc. It is possible they might even use the folder structure to show the status of their images, for print, for web, for presentation, etc. A Sports Photographer may organize by event and personalities and a Fashion Photographer by shoot, model or client.

Many fellow authors and blog posters on Lightroom and on Digital Asset Management (DAM) have suggested that you should use the image folder structure to categorize your images. For some this might still work when using Lightroom, but I suggest that sooner or later this overly complex methodology could tie you in knots.

If we take an example where an image is in more than one 'category' (something that can happen a lot) what do you do? Create a copy? In which case you have a duplicate image. Or if some element of your categorization changes, such as its place in the hierarchy then will you end up having to restructure your hierarchy and naming system?

I typify this methodology as 'Fighting Lightroom'. You are, in effect, trying to make Lightroom fit a working methodology which doesn't use the power of Lightroom's database, keywords and collections features. In a way this is an 'old style' File Browser methodology.

File Browser versus a Database Application

Many other products in this space are simple File Browsers. You point the application to a set of folders or an image library and they will traverse the file system and rapidly generate some thumbnails, which allow you to see what is on a disk and search by filename.

SQLite

SQLite is a small software library that implements a relational database management system. It is linked in to the application that uses it and the entire database is stored in a single, cross-platform file on the user's machine. The database gets locked when the application is used, which means it is mostly used for single-user applications. Applications such as Lightroom, iTunes and Aperture all use SQLite.

In Lightroom the database is the .lrcat file that can be found where you have set it in your Preferences.

For more information on SQLite:

http://sqlite.org

Lightroom has at its heart a **SQLite** database, which not only catalogs the location of the files on your disk, but also all of the EXIF Metadata associated with the images, any Metadata you add, and the image edits you make. As it is a relational database this can create 'mappings' between sets of files, types of file and user generated categorizations. In Lightroom these are called Collections.

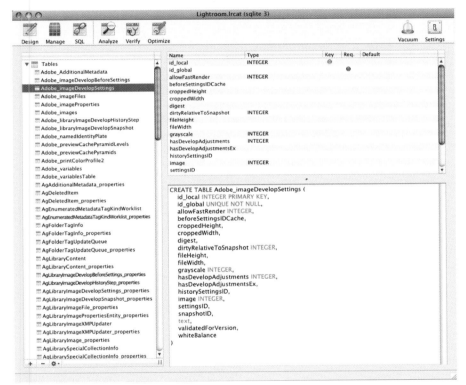

Lightroom is a database-based parametric editor, which means that you are not editing the image directly, but you are creating a set of instructions (or recipes) to apply to the image on export. These editing instructions are saved in the SQLite database and either in .xmp sidecar files or in a discrete metadata space with in a DNG file when you invoke **Cmd S**.

What you see on screen is an advanced set of Previews which you render either on image import or as you move around the

Fig 4.1 The Lightroom.lrcat file, as viewed in SQLite Manager. It is advisable not to make changes to this database other than in Lightroom itself as you could end up with a corrupted and therefore useless database.

Fig 4.2 A Raw file, originally 8.3 MB with an .xmp sidecar file, 8KB; converted to DNG, with a Large Preview, 9.2 MB, No Preview, 7.3 MB and with the original Raw file embedded 17.4 MB.

Raw and DNG

Raw is the generic name that is given to Camera Manufacturers' files. Each manufacturer has their own version of these Raw files, in some cases there are different subversions of these Raw files. Typical file extensions include:

Nikon: .NEF
Canon: .CRW, .CR2
Olympus: .ORF
Pentax: .PEF
Fuji: .RAF

When Lightroom uses these files, it will not edit them; it treats them as master files. Instead it creates 'sidecar' files .xmp, which contain all the editing and metadata edits you make.

Adobe released the DNG format as an attempt to create a Raw file standard. Each of the manufacturers' formats is proprietary and undocumented. DNG is a wrapper format which allows manufacturers and users to convert their native Raw format files into DNG, retaining private spaces for manufacturers' *secret sauce*, a space for embedding color profiles, and a space for the storage of the data that would otherwise appear in the .xmp file.

Lightroom interface. All of this information is cataloged within the database. The generation time of the Previews is also captured within the database so that Lightroom knows when to generate new Previews, use an existing one and where they are stored.

This system is much more complex than the File Browser method. You still 'point' Lightroom toward a set of images but the overhead of what it does with that information, building Previews and applying Metadata, means that the import process can take more time. Selecting different options at import allows you to lessen the time the process initially takes, but all you are really doing is postponing some of the wait time. We will look at the options in more detail later.

Working With Lightroom

Because of this different approach to managing your Catalog, understanding how best to work with Lightroom is necessary.

In the early days of using Lightroom, I tried to make it fit **my** working methodology, which had been based on the File Browser capabilities of Adobe Bridge, and frankly I struggled to get to grips with the right way to work, and very nearly gave up! Then, not only did Lightroom's methodology get changed during

the original beta process, but I, sensibly, adapted aspects of my workflow and, sure enough, Lightroom and I clicked!

So how best to make it work?

File Structure by Date

I maintain that the logical and obvious way to structure your Catalog is in date order. This provides a natural division of files; one that has an obvious order but not one that gets bogged down trying to describe too much about what is in that folder. That categorization task can be left to Lightroom's Keywording, Collection Sets, Collections and Smart Collections. After all the advantage of Metadata combined with a Database is that it does the hard work for you!

Some camera manufacturers have adopted DNG as the format their cameras create. It is hoped that more will follow. Some advantages of DNG include, lossless compression, ability to embed the Raw file in the DNG, creation of large previews and no .xmp sidecar files!

For more information on DNG visit:
http://tinyurl.com/rw8sx

Fig 4.3 My file structure.

My system uses a root folder to store all of my images. (I don't tend to use many disks to spread the load, instead I use extra disks to keep a copy or copies of my file structure). Then Years, Quarters, Months and Dates to segregate the files. This will be mirrored in the Lightroom interface. Segregating into Quarters is just something I do to create a more granular drill down of the date structure, I don't make a strong case for it!

Fig 4.4 Augmenting the file structure with more descriptive names.

85

If you feel uncomfortable with that bare minimum of information you could add a more descriptive name to the date folder. For example the folder **2008.07.13** is a nature shoot at a local nature reserve, called Cornmill Meadows. I could easily add the name as a suffix to the date. I keep the date first as it will create the natural sorting order.

Fig 4.5 Lightroom's Import Dialog box.

The date is formatted in a standard ISO format, again to order the folders correctly. Unfortunately, in this case, I had created this folder naming structure long before Lightroom was first released, and Lightroom doesn't support dot separation by default, instead it uses hyphens to separate. It is possible to edit such details in the Import dialog box, but if you are importing a multi-day shoot from a card it can be very tedious to edit the names!

I am hopeful that Adobe will allow this structure to be enhanced with Presets in future versions, until then I use an alternative import strategy, which I mention later. But you might prefer to use hyphens as it is the easy thing to do!

Fig 4.6 Lightroom Preferences and the file handling for JPEGs next to Raw files.

In structural terms, I don't think you really need to do any more than that. If you shoot Raw and JPEG files and you want them treated as separate files then you will need to set this up in Preferences (**Treat JPEG files next to raw files as separate photos**).

The power of Lightroom lies within the application!

Creating Catalogs and Importing

Whether you have some legacy images structured on your disk, or you are about to import some images for the first time, you will need to create a Catalog in Lightroom to store your images.

Start Lightroom and a catalog will be created in a default location on your computer:

Mac: ~/Pictures/Lightroom
Win: Documents and Settings/[Username]/My Documents/My Pictures/Lightroom

It is recommended that you store this Catalog on your fastest hard drive with the fastest connection, but ideally on a separate disk from your image store. As mentioned in the previous chapter, SATA or eSATA would be excellent choices.

Let's accept the default choice. However, before begining the first import it is worth setting some preferences and editing

Naming Catalogs

There were a few problems spotted with version 2 when it came to catalog naming. Using apostrophes or ampersands in the name caused errors in certain circumstances. I would advise using one simple word for the catalog name; Lightroom is a good choice!

This bug is likely to be fixed in version 2.1

the Catalog Settings. From the Lightroom menu, select Preferences….

Preference Screens

General: I select a sound to play when the import process has finished, as it can take a while.

Presets: I make no changes.

Import: I set the DNG Preview size to be Full Size.

External Editing: I make no changes.

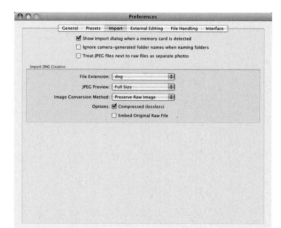

File Handling: Using this cache speeds reopening files in the Develop Mode and rebuilding of Library Previews. If you have the disk space then it is worth boosting this to 10 GB or even up to 50 GB.

Interface: Here I have changed the Panel End Mark to be Box. You may not care much about this!

Fig 4.7 Preference Screens.

Catalog Settings

The next screens to look at are the Catalog Settings. Either reached from the **Lightroom > Catalog Settings...** menu, or by pressing **Go to Catalog Settings** in the previous **Preferences | General** panel.

Here we will make some important settings that can improve the use of Lightroom.

General: This tells you where your catalog is in your file system, when it was created, last backed up, last optimized and how big your Catalog is.

It is worth checking this on a regular basis, so that you can keep track of the status of the Catalog.

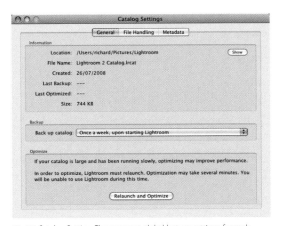

Fig 4.8 Catalog Setting. These are not global but are settings for each individual catalog.

You can set how often to create a backup of your Catalog. In this case I have set it to **Once a week upon starting Lightroom**, you might want to create a backup more often than that. I used to have it so that I was asked to backup everytime Lightroom was started, then I could choose whether to do so. The Catalog is the database so is a very important asset.

It is up to you, but it is very important to create regular backups of your Catalog, in case it gets corrupted. Corruption is a very rare ocurrence but the way to look at it is how long you could go without a backup and not lose too much data. That might be daily with a high volume of shooting, or weekly if you are a more occasional shooter.

I think it is good practice to make a backup before and after a large import. Every two to three weeks you should go to the Catalog folder and delete some of the older ones. I would tend to keep only the last two or three as they will take up extra, and probably uncessessary, disk space. Over time you could be using a few Gigabytes.

This is also the screen to visit to **Optimize your Catalog**. If you have performed a huge import, have deleted a large number of images, or performed a large number of metadata edits, it is worth performing a Catalog Optimization. I tend to optimize on the first day of the month. The process creates a backup beforehand, so your data will be safe!

If any problems do occur, you will get a warning; the old Catalog will still be usable, but you may be starting to have problems. If you are, then now is the time to login to the Adobe User to User forums, for expert help. See the **Resources** chapter for more details.

File Handling: This is the screen to setup how and when you want to use Previews. The rule of thumb with Standard Previews is to set the size to that which closely matches your screen width, in my case my monitor is 1920 pixels wide, and because I have plenty of disk space, I set the Preview to 2048 pixels whereas a laptop may only need 1024 pixels.

The quality can stay at medium, as large will tend to take longer to process for little gain.

Fig 4.9 Catalog Settings: File Handling.

Previews

Knowledge about how and when previews are used and generated is essential to understanding how Lightroom works. The logic for this is fairly complicated.

It is worth remembering that when you are making edits in Lightroom you are never working directly on the Raw/DNG file, you are working on an advanced set of Previews. There are several sorts of these that Lightroom generates. If you imagine an inverse pyramid, starting from the bottom up.

Sidecar Previews are the lowest form of Preview life, they are often produced by cameras as tiny thumbnails. Lightroom will use them to generate a quick view of the images you are importing, then they will be discarded.

Embedded Previews range from small, to vast (depending on your camera), again Lightroom will use them where it can but the bigger they are the more it could slow Lightroom down, as it will

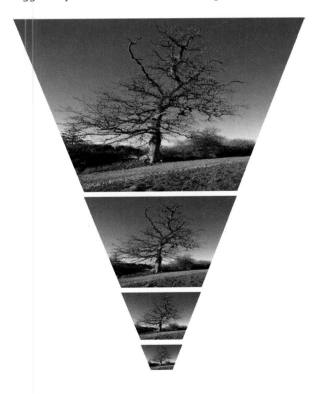

Fig 4.10 The Preview Pyramid. **Top to Bottom:** 1:1 Previews, Standard Previews, Embedded Previews and Sidecar Previews.

spend time grabbing the embedded previews, then it will render Standard Previews after that.

Standard Previews are used by Lightroom when navigating in the Library Module and viewing images at the basic size within the Develop Module.

1:1 Previews: at some point Lightroom will need to generate 1:1 Previews. This can occur at import, it can be done on the fly as you move into the Develop Module and zoom, or you can manually select all the images in the Library and select **Library > Previews ≥ Render 1:1 Previews**.

1:1 Previews are the important ones, they are rendered to be accurate to the Raw file in size and color, so your strategy for generation and management is important.

In the example below I have imported some images without generating Previews. When I zoom in, I will be greeted by a **Rendering Larger Preview…** bezel, this should only take a few seconds, but it can be disruptive to your workflow.

If you switch to the Develop Module, and zoom into an image, you will then be greeted by a **Loading…** bezel. Lightroom is now rendering a 1:1 Preview, so that you will be able to work on the image at the best quality. Even on a fast system this rendering process could take 3 seconds, depending on the Raw file size generated by your camera, so you can imagine that if you are editing a few hundred images with no previews, you might end up very frustrated.

Fig 4.11 The Rendering Larger Preview… bezel.

If I render 1:1 Previews after import, by selecting **Library >
Previews > Render 1:1 Previews** from the menu it takes about
1 minute for 40 images, but now my waiting time when I move
around in the Develop module is much reduced.

Fig 4.12 The Loading . . . bezel.

So rather than generate Previews after import, or on the fly,
I prefer to generate 1:1 previews on import. It will take longer to
perform the import process, but I can be doing something else in
the meantime.

If time is of the essence and a deadline is looming, you
might prefer to stick with Minimal previews on import; it
will get your images from card to Catalog as quickly as
possible.

Preview Management

How long you choose to keep these 1:1 Previews depends on
how you use your Catalog. If you are forever dipping in to the
older images in your Catalog, then you may want to set the
Automatically Discard 1:1 Previews to **Never**. If you tend to
work on recent images, then setting it to discard them after
30 Days is probably a sensible compromise. I have never used
One Day or One Week, but a huge image turnover might make
those options more attractive. The size of your **Lightroom 2
Catalog Previews.lrdata** file will probably be the best guide. On
a Catalog of 12 000 images, never discarding the 1:1 Previews led
to a 40 GB Preview file.

Fig 4.13 Selecting the discard time for 1:1 Previews.

The final part of the Catalog Settings dialog box is **Metadata**, and the main question here is whether you want to automatically write changes into XMP, or whether you prefer to do it manually.

Fig 4.14 Catalog Settings: Metadata.

In Lightroom a standard **File** > **Save** doesn't exist. Because of the different methodology used by Lightroom, that you are creating 'recipes' to apply to files at Export, you never save a file. What you can do is write the changes you have made (be they keywords, or develop settings) to either the .xmp sidecar or the XMP space

in the DNG. This is achieved either automatically, if you check the box in **Catalog Settings | Metadata > Automatically write changes into XMP**, or manually by selecting the images you wish to save the metadata edits and pressing **Cmd S**.

The former can slow you down, although it is a background process. Personally, I prefer to perform manual saves, you just have to remember to do so on a regular basis. Your changes, whether saved or not are kept in the database, but not written to the file or sidecar until you save.

If you are working with other applications or other users in a studio, automatically saving the metadata edits may make more sense, so that your changes are always kept up to date.

If you find Lightroom is slow, then uncheck the box and see if that helps.

Import

Finally we reach the stage where you can import some images to Lightroom!

Whether your images are already on disk, or on a card ready to import, now is the time to press Import.…. When you do so you may be offered a choice of importing from disk or from card (if you have inserted a card into a card reader). Choose the one that is relevant to your needs. In this case I will start with a card import.

You can set Lightroom to automatically fire up the Import dialog box when you insert a card. Depending on the peripherals you attach to your computer, you might prefer to keep this option off. **Preferences > Import Show import dialog when a memory card is detected.**

As you may have noticed there are several options in the dialog box and we will walk through them.

The dialog box is divided into sections, first up is File Handling, you have the option to **Copy photos to a new location and add to catalog**, or you can **Copy photos as Digital Negative (DNG) and add to catalog**. The former means you are just importing Raw files, the latter that you are converting the Raw files to DNG. I prefer to use DNG in my workflow, so would choose the latter.

Card Readers

It is highly recommended that you use a card reader to grab images off your camera, as connecting up your camera can sometimes cause problems and/or image corruption.

Card readers come in many flavors, USB, USB 2, Firewire 400, Firewire 800 and Express Card and even built-in.

I use a Firewire 800 card reader on my main desktop machine, and for a laptop a USB 2 card reader.

Some cards are not compatible with all card readers, so it is worth experimenting, and sticking with one brand of card and reader.

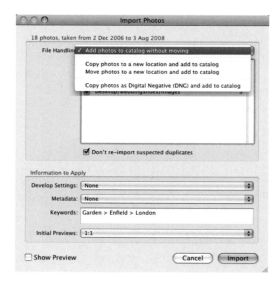

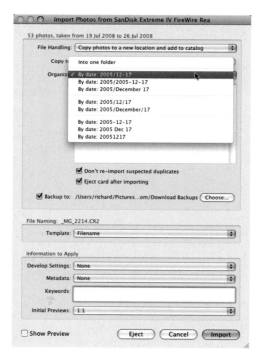

You are then asked where you would like to copy the files to. In this case the default location is on the same disk as my Catalog, and I will accept that, but I recommend you store your image library and the Lightrooom Catalog on separate disks.

If you import files already on your disk this part of the dialog offers other options.

Add photos to catalog without moving, imports the images and leaves them in their current location.

Copy photos to a new location and add to catalog, allows you to choose another place to store your images, by copying the files.

Move photos to a new location and add to catalog, allows you to choose another place to store your images, by moving the files.

Copy photos as Digital Negative (DNG) and add to catalog, converts the photos to DNG as previously mentioned.

Next comes **Organization**. This is where you tell Lightroom how you want the files imported into folder structure. The default is **By date: 2005/12-17**. As I mentioned, none of these methods caters for my personal structure, so I could go in and edit the naming structure by hand if I wish. Click the date field to edit. The closest to my preferred structure is **By date: 20051217**, so I have selected that.

Two further options allow you not to import duplicates and to eject the card after importing. I leave both of these checked. If you have not formatted your card between imports, checking the **Do not re-import suspected duplicates** will only import the newest images.

Backing up is very important, and it is worth doing this on import. It would be sensible to choose a third disk to store the backup, if you can.

You can choose to rename files on import, either by using one of the suggested naming conventions, or

by using a Filename template (see the Presets chapter for more information). I tend to import using the original filename, but if you are going to go through 9999 images in a short space of time you can run into conflict with duplicate filenames and too many files called _MG_0001.CR2! For this scenario you will need a Filename Template. There was previously a disadvantage to using a Filename Template in that the original filename didn't get embedded into the Metadata. But in version 2 changes to the filename are retained, if performed in Lightroom.

Upon Import you can apply Develop Presets and apply **Metadata Templates** to your imports (this is described in more detail in the Presets chapter).

It can be advantageous at this point to enter high-level Keywords. In this case all of the images on the card, while spread over several days, were all taken in my back garden, so I could add the location details. Obviously if one card contains many locations and themes there may be no benefit to applying high-level Keywords.

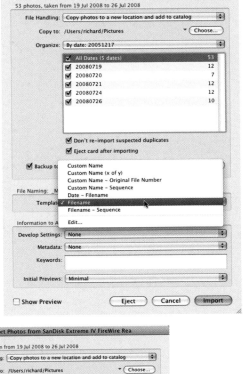

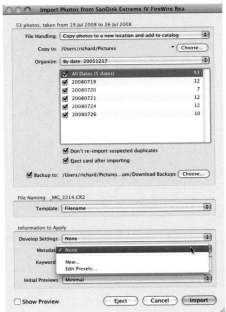

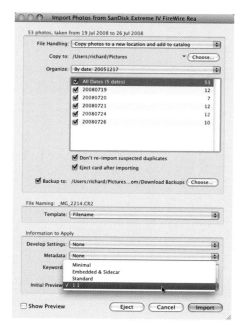

Previews can be rendered at import and you have the choices mentioned previously. However, I am going to make a simple recommendation; unless speed is of the essence, then **Render 1:1 Previews** now on import. It takes longer to import, but it will speed up your workflow once you are in Lightroom.

Checking the **Show Preview** button, further opens up the dialog box, so that you can scroll through the images and maybe deselect any that are immediate and obvious rejects.

If we were going for speed, this 52 image import could take 22 seconds (by simply importing, not backing up and not rendering previews). If we perform the same import, but convert to DNG, backing up and rendering 1:1 Previews, it could take nearly 5 minutes.

The backup facility copies the original Raw files to your backup location, so the files will exist in two states on your disks, in Raw and DNG. As the intention is to use the DNGs, I recommend copying the Raws off to archival media.

Alternative Import Strategies

As I have mentioned, I use a different method to import my files from camera to disk, one that takes place before I open Lightroom. In part this is because of my folder naming structure (which was a legacy I have never got rid of!) and I prefer to create more than one back up on import.

For this I use a piece of third-party software called **ImageIngester Pro,**

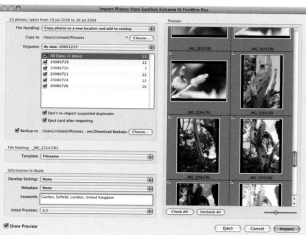

Basepath Software

Marc Rochkind runs Basepath Software and has also created the free **LRViewer, http://tinyurl. com/5llezr** application which allows you to view a Lightroom Catalog, without having a copy of Lightroom.

http://tinyurl.com/6j6u3a. This was created by Marc Rochkind in response to Peter Krogh's *The DAM Book*. The software automates the many tedious aspects of importing, allowing multiple backups, addition of Metadata, conversion to DNG, importing from multiple cards (up to 8).

Fig 4.15 The final import.

Fig 4.16 ImageIngester Pro 3 (beta).

The new version 3 (currently in beta as I write this in August 2008) has a redesigned interface and is a big leap forward.

Because of the flexibility of the import process, I can create templates for folder names (unlike Lightroom), naming structures and Metadata. It also keeps a track of imports and creates comprehensive log files of your imports in case there are problems.

It also allows you to add Simple Macros so, for example, I can embed the original filename in Metadata; although this is now handled in Lightroom 2. ImageIngester Pro is also database-based (another SQLite application) and I believe it is worth looking at as a more sophisticated import tool, until there are a few improvements in Lightroom's import procedure, or even if you are just a fan of the *DAM Book's* workflow.

Backup

We have seen that both Lightroom and ImageIngester Pro allow one or more backups of your image data and I am a firm believer in ensuring that little is left to chance.

In **The Ideal System** chapter we looked at a method of Synchronisation to ensure that your Catalogs, Previews and Images are all kept in more than one place, and if you haven't yet thought about your backup strategy, there is no better time than your first import!

The First Pass

We now turn our attention from the Import process, to the actual use of Lightroom to go through the images we have imported.

Firstly it is worth zipping through them to see if there are any obvious Picks or Rejects. At this level we are making pretty quick judgements, but we are not deleting anything yet, so an image that looks like a Reject, but is actually the basis of something interesting can still make it to be one of your Picks.

There are several ways to approach this. You can run through a quick overview in the Lightroom Grid mode [**G**], you could use the Loupe mode [**E**], or even use the Library Quick Slideshow.

There are advantages and disadvantage to each of them. The Grid method is probably the quickest, but you might overlook images

Fig 4.17 Three ways to do a first pass. Grid, Loupe or Quick Slideshow.

because of the size of the thumbnails (although they can be increased). The Loupe is next quickest but will be slower than Grid.

Slideshow will be the slowest, but also the 'calmest', least distracting method of viewing the images. Allowing you to set the pace of viewing, and offering no distractions.

In each case we are simply looking at Picks and Rejects, and these tools are active in all three modes. Using the **X** for Reject and the **P** for Pick as you go through will apply the flag to the image.

If you are using the Grid or Loupe modes, holding the **Shift** key down as you Pick, Reject, Rate or Color, will apply the flag to the image and move on to the next. Pressing the **Caps Lock** key, does the same, but you don't need to press the Shift key. This is a great timesaver when performing the first pass.

So, pressing the **Caps Lock**, I will use the **P**, **X** and **0** key (0 means it is not Rated, Picked or Rejected), and we can quickly wheedle out obvious Rejects.

When I have finished the first pass, I will then switch back to the Grid [**G**] mode, for a quick visual check.

Notice that the Rejects are shown dimmed in the Grid, this is a new feature which gives you a quick visual clue to what's in and what's out.

The Rejects

I will then take a close look at the Rejects; open up the **Library Filter** [/] and select the **Reject Filter Flag**, this shows only the

Fig 4.18 The Rejects shown dimmed – a new feature for Lightroom 2.

Fig 4.19 Using the Library Filter to show only the Rejects.

images you selected as Rejects, then go back into the Loupe Mode and again cycle through these images.

If I am happy with my initial decision that these Rejects are no good, I will Select All and delete them from the disk. Any that I am unsure about would have the Reject flag removed. This has to be done on each image with the mouse. In this case I will delete 17 out of 53.

You can of course just remove them from the Catalog, but I like to be ruthless and delete the confirmed Rejects from the disk.

Fig 4.20 Deleting the Rejects; the default option is to Remove the Rejects from the Catalog, or you can choose to Delete them from your disk.

Dealing with the Undecideds

Next up we will look at the ones I couldn't decide they were Picks or Rejects. Back in the Library Filter, select the **Unflagged Photos Only** attribute. In my initial pass this threw up 11 images. I again go through in Loupe Mode.

I am more likely to spend a bit longer on these images, perhaps zooming in to **1:1 [Spacebar]**, or even making some **Quick Develop** adjustment, to see if there is something more in the image. I might also use the **V** key to **Convert to Grayscale**, in case I have missed something there.

As it happens, on this pass, I decide to Reject one of the images as it is not quite in focus, and decide not to promote any to Picks.

If I am unsure about two, or more, similar images I can use the **Compare** mode [**C**], to make critical judgements and attempt to choose the best. In this case the left image is slightly less sharp, so is the one Rejected.

I am left with 10 undecideds which I will keep. If I were being truly ruthless I would probably delete those as well as they haven't hit the mark, but in this case I feel generous!

Quick Develop

This feature is very useful for applying minor adjustments to an image or all the images in the Library Module. The adjustments made in Quick Develop are relative, rather than absolute, and clicking the single arrow adjusts Exposure by smaller increments than the double arrow. The amounts vary with each adjustment:

Type	>	>>
Exposure	0.33	1.00
Recovery	5	20
Fill Light	5	15
Blacks	1	10
Brightness	5	20
Contrast	5	20
Clarity	5	20
Vibrance	5	20
Sharpening	5	20
Saturation	5	20

Sharpening and Saturation are revealed by holding the Option Key down.

Fig 4.21 Using the Compare mode to choose between two images.

The Picks

There are 25 photos left to check through that are flagged as Picks. So I will now go through these. The questions I will be asking myself on this pass are:

1) Is it **really** good enough to be a Pick?
2) Does it need cropping or rotating?
3) Would it benefit from some Develop adjustments?

If I have taken an image sequence, for HDR imagery or Panorama, I will be giving them a **Color Flag**, so they are easy to spot. In this case 9 of the 25 are meant for processing as a High Dynamic Range image (HDR), so I will Rank them with a **6** which gives them a **Red Flag**. They won't get any other ranking as they will be heading for external editing in Photoshop or Photomatix Pro. If they work out as an HDR image, then they will come back into Lightroom having been processed as a TIFF or a PSD file.

That leaves me to Loupe through the other 13 images. With these I will begin to rank them between **0** and **5**. I may still decide that a Pick is a **0**, but anything that gets a **1** or greater rating is what I consider a **Keeper**. As you would expect a **5** rating is only for the best, so I am generally happy on this pass to stick to **0-3**, unless an image really leaps out.

For this pass, I will use the **Library Filter** to select the Picks and all Colors except Red. This hides those destined for post-processing.

Fig 4.22 Rating the HDRs **6** for post-processing, this colors them red.

Fig 4.23 Using the Library Filter to select the Picks and all Colors except Red.

Back in Loupe Mode, I start the more considered process, with the **Caps Lock** key pressed. I will also hide the **Top**, **Left**, **Filmstrip** panels and the **Toolbar** [**T**], so I can concentrate on the image more fully. I could also use the [**L**] key to go into **Lights Out** mode. Other useful keys to enable you to view the image in isolation are **Tab**, **Shift Tab**, and repeated pressing of the [**F**] key, which takes you into the Full Screen with Menubar mode, and another press takes you into full Full Screen mode.

Fig 4.24 Panels hidden, Lights Out Mode.

Fig 4.25 Other screen modes: pressing **Tab,** hides the side panels; pressing **Shift Tab** hides the side and top panels; pressing the **F** key goes into Full Screen with Menubar mode; another press of the **F** key puts you into full Full Screen mode.

As this is a more detailed look at the images, I may use the Quick Develop tools to make minor adjustments, remember that Quick Develop adjustments are relative rather than absolute. They are mainly being used to make adjustments to **Exposure**, **Blacks** and **Fill Light**. Occasionally, I might switch to the **Develop Module**, to **Crop and Straighten** [**R**], or make absolute or more precise changes.

Rating and Keywording

I decided after going through the Picks that there were 5 images that deserved at least a rating or 1 but I didn't go any higher, as they were interesting, but not that interesting! I can always reconsider later.

As mentioned, the system I use considers anything that has a rating of 1 or more to be a Keeper. Keepers are the ones I will apply more Keywords to and I will also Rename them. I rename them so that they are more easily spotted, and it makes archiving simpler as I will then archive all the Keepers in yet another space.

I like to keep track of the orginal filename just in case a new, even whizzier piece of Raw processing get released and I might need to return to the original Raw files at a later date. This new piece of software might not support DNG files, so tracking down the original file needs to be as easy as possible. However, I don't envisage moving away from Lightroom!

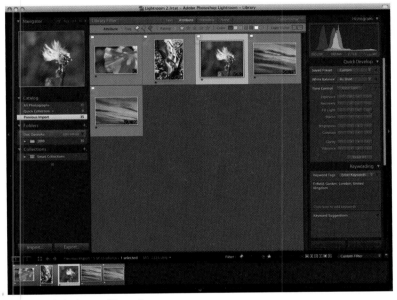

Fig 4.26 The final selection of 'Keepers'.

I am now left with 5 images to Keyword. How you keyword depends on your needs, you may need to keyword for Stock Libraries, or simply for your own archive processes.

As you work with Lightroom you will build your own set of Keywords, but you may want to invest in a Keyword System. One of the most well known is the **Controlled Vocabulary**. This takes a structured and analytical look at the way to create and use Keywords. It is also possible to buy a Keyword

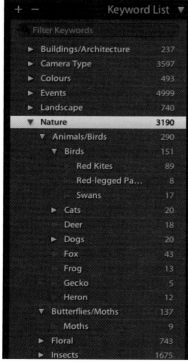

Fig 4.27 Top: Keywords in Lightroom; Bottom: Exported Keywords in a Tab Separated Text File.

list to help you in the process **http://tinyurl.com/6byokc**. This provides approximately 11 000 terms organized in a hierarchical structure. Another is the Keyword Catalog **http://tinyurl.com/6zrv2z**, containing 37 000 keywords, phrases and synonyms.

More information can be found at the Controlled Vocabulary website **http://tinyurl.com/6byokc** and another Focal Press book *Digital Photo Management* by the creator of the Controlled Vocabulary, David Riecks **http://tinyurl.com/5myuwg**.

Of course if you want to be really dedicated, before you import any images you can create or import the keyword list you would like to use. Lightroom Keywords are simply tab and return separated text files, each level of hierarchy is a further tab press.

Metadata

The final aspect to the Library is the Metadata panel. If you hadn't assigned a **Metadata Preset** to your images when you imported them you can apply one now, or you can fill in the various categories as you work. Metadata Presets are discussed in the Presets chapter, but essentially it assigns copyright, IPTC information and now with version 2 you can add Keywords to the Metadata Presets as well.

Geocoding Images

As GPS becomes more prevalent, attaching location details to photos is becoming popular, and for some photographers essential.

Lightroom has support for Geocoding of images and will display the GPS position details if embedded. If you don't have a GPS unit built into or attached your camera, you will have to use other methods to input the information. These can be either to use a separate GPS unit or use online mapping tools.

A built-in, or attached unit, is more likely to add the GPS information to the EXIF data of the image, so will automatically appear in the Metadata Panel.

If you use a handheld device or want to use an online mapping service, then you will need some third-party software.

On the Mac, I use **HoudahGeo** http://tinyurl.com/66ke4e and for Windows, I have heard good reports about **Geosetter** http://tinyurl.com/67vs6z and **RoboGeo** http://tinyurl/25dllo. They all do essentially the same things. One of which is to import data from a GPS device and match the time you shot the image with your position. This means that the camera's clock needs to be compared with the GPS device's clock. You can normally set any offset in the applications.

The other way is to use online mapping services, such as **Google Earth http://tinyurl.com/cw4r9** to locate your position when you took the image. Using HoudahGeo, I will show a runthough of the process.

In Lightroom, select the images you want to geocode, and press **Cmd S**. This is to save the metadata edits you have made to the images, as the following process will eventually write metadata back to the image after the geocoding.

Open up HoudahGeo and import the images to geocode.

Select them all and press the button highlighted **Geocode selection using Google Earth**. This will open Google Earth. Navigate to the location

Fig 4.28 The Metadata Preset dialog box.

Fig 4.29 A Dawntech GPS unit attached to a Nikon. Image courtesy of Dawntech.

where you took the images. Press the **Geocode** button on the HoudahGeo sub-window positioned below Google Earth.

Then return to HoudahGeo, the Longitude, Latitude and Altitude now appear in the main window. Press the **Write EXIF/XMP** tags button. This will write the **geocode** information to the EXIF space in the DNG or the .xmp file of the Raw image.

Return to Lightroom and with the images selected, select the **Read Metadata from Files** menu item. This reads in the metadata edits made in HoudahGeo and updates the Lightroom Metadata panel, with the GPS information.

Fig 4.30 A Garmin handheld GPS device. Image courtesy of Garmin.

Fig 4.31 Selecting images to geocode in HoudaGeo.

Fig 4.32 Geosetter and RoboGeo for Windows.

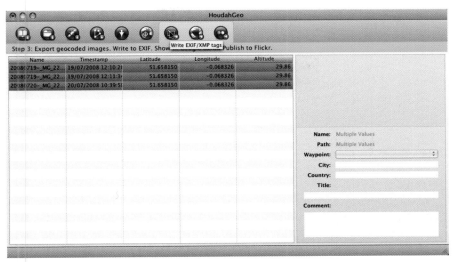

Fig 4.33 Selecting the location in Google Earth.

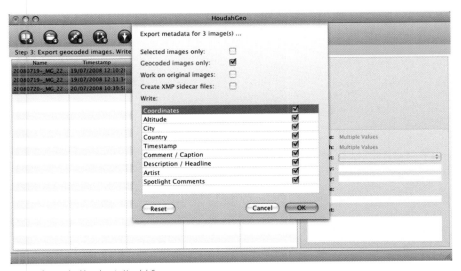

Fig 4.34 Saving the Metadata in HoudahGeo.

Smart Collections for Workflow

If you want to use this functionality extensively, it is worth creating a **Smart Collection** or a **Library Filter** to help you find images that have been geocoded, and those that haven't. I have

created a couple of **Library Filter** presets to do just that. They are available at **http://tinyurl.com/5h5q4y**. Install them in:

Mac: `~/Library/Application Support/Adobe/Lightroom/ Filter Presets/`
XP: `C:\Documents and Settings\<username>\ Application Data\Adobe\Lightroom\Filter Presets/`
Vista: `/AppData/Roaming/Adobe/Lightroom/Filter Presets/`

Fig 4.35 Reading the Metadata in Lightroom and the change to the Metadata panel.

To create a Smart Collection of those images still to be Geocoded, create a new Smart Collection, choose the following options and name it. Then press **Create**. Your Collection list will now include **Not Geocoded**.

It can be daunting to Geocode or Keyword several hundred images in one go; it is much more managable to break such tasks down. Creating Smart Collections as a To Do item, is a great way to make some of the more tedious chores easier to manage.

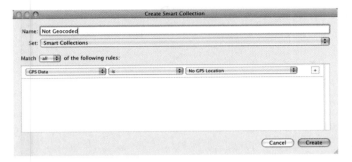

Fig 4.36 Creating a Smart Collection in Lightroom.

During idle moments you can revisit the list and see the numbers reduce as you work through them.

Collections

So we have reached a point in our workflow where we have Imported images, worked through which are **Picks** and which are **Rejects** and ended up with a set of images we can consider **Keepers**. They have been **Keyworded** and **Geocoded**, so now we probably want to further organize our images.

Collections are simply virtual groupings of your choice. The idea being that you have your images structured using your folder system, but that some or many of those images will fit in to categories that transcend the folder structure.

Earlier in the chapter, I advised that for a Wedding Photographer rather than organize the folder structure as shown below:

Fig 4.37 A folder stucture I don't recommend!

which is very stuctured but also hugely inflexible, they should be organized by date and perhaps wedding name. An image in 'Brides Family' could also be in 'Friends'; which might mean duplicating the image, which is really counter to the way Lightroom works.

113

Fig 4.38 A recommended folder structure.

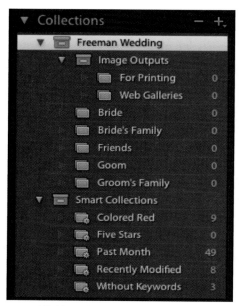

Fig 4.39 A Wedding Collection Set.

Fig 4.40 A Landscape Collection Set.

In the second example, we are free to use Collections to do the organization. Here I have created a **Collection Set** called Freeman Wedding, this will contain all the **Collections** and further **Collection Sets** relating to this wedding. Images that are in one Collection can also appear in another as they are simply virtual categories. No files are moved in this process, the master image is unaffected. This is a grouping created in the database.

I have used a Collection Set within the Freeman Wedding Collection Set for any images that are for output. So to produce a Wedding Gallery for the Bride and Groom all of the Picks would go into the Web Gallery Collection, and any that have been requested to be printed can go in the For Printing Collection. Another Collection could be created for images to create a Wedding Book.

Each Wedding would have its own Collection Set and you might create further Collection Sets by year and by month if business is good!

A Sports photographer would end up with different categories but the same overall concept. A Documentary or Landscape photographer might be more Project based, so Collection Sets could contain overall themes, and Collections might denote Black and White, Color, For Competition etc.

Add to that the power of the new Smart Collections and as we have seen with Geocoding we can use them to help with task-based workflow allowing you to create virtual collections of images to Keyword, to Geocode, to Rate, etc. The organizational possibilities are endless!

Of course you don't have to follow the Collection structure shown, it is just a way of organizing your images instead of a file-based structure.

Beyond the Library Module

At this point you have done virtually everything you might want to do in terms of stucture and related workflows.

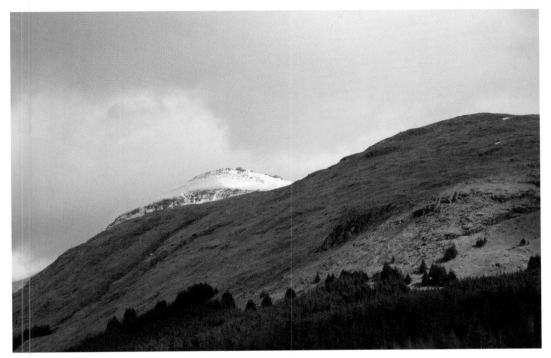

Fig 4.41 An image for developing.

The next port of call is most likely to be to use the Develop Module to further refine images or batches of images.

The new features to be found in the Develop Module have been described in the **What's New in 2?** chapter. The next chapter looks at a Develop Workflow for one image.

A Develop Workflow

Photoshop has for many years been the *de facto* standard for image editing, and frankly it still is. But with Lightroom 2's new capabilities many photographers are finding that they are visiting Photoshop less and less to perform edits. For certain actions, merging to HDR for example, you will still need Photoshop or another third-party editor.

With the new selective editing tools and the graduated filter, Lightroom's creative abilities have greatly improved. With the edits being performed in Metadata, rather than pixels or Adjustment Layers, you have a completely different creative editing paradigm.

In this chapter we will look at the Develop Workflow options for a single image. The aim is to show the thought process that occurs when working in Lightroom, as well as some of the techniques you can use to make critical judgements.

Photographers and Photoshop users have a long tradition of editing and performing creative adjustments 'by the numbers'. Lightroom takes a slightly different approach; you can still use numbers, but perhaps the difference is that you use sliders to get the image looking right on screen.

So it is essential to have your monitor profiled accurately and we have covered that in an earlier chapter.

The image I will use in this chapter was taken in Scotland in April 2008. Unfortunately, I didn't have any filters with me on the trip, and as I subsequently found Neutral Density and ND Grad filters are essential in Landscape photography! The light in Scotland at that time of year can be quite clear (if it isn't raining!), so a straight Landscape photo will have to deal with a range of contrast, but you might find some haze as well. It would certainly be better to have had the filters mentioned as well as a Polarizer and some UV filters. Capturing the shot in camera is certainly preferable!

Fig. 5.1 The original image.

But all is not lost. Lightroom's new features, and its existing solid set of Raw development tools, can rescue images as well as provide extra creative opportunities.

Looking at this image, I felt it had promise. There are some faults, but there is a good range of tones, with interest in the bottom right in the pine trees; there is a lovely mix of colors with the contrast between the green of the newer trees and the brown of the older ones. The shaft of light highlighting the land above the pine trees interests me as well.

There is a slightly annoying problem with the continuation of the mountain in the distance in the lower bottom left of the image, but that can be cropped out. The clouds have some depth and the snow-capped peak needs to be made to shine.

The Develop Mode

Enter the Develop Mode and set up the workspace to offer you the maximum workarea. I have hidden the top, left and bottom panels and did this Manually rather than Auto Hide, as Auto Hide will pop the panels open if you go close to them.

I will also drag the right hand panel as wide as possible, this will give me the finest control with the sliders.

Fig. 5.2 The Develop Mode, with top, left and bottom panels hidden and the right-hand panel maximized.

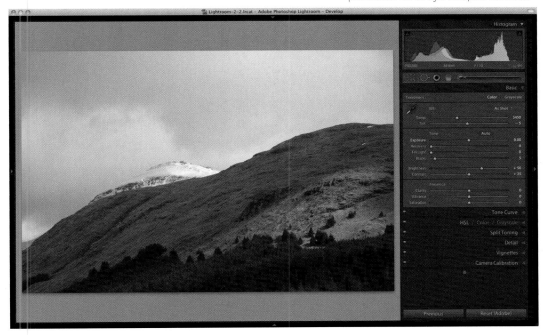

The first action to perform is to Crop and/or Rotate, in this case Crop. Either select the Crop tool or simpler still, press the [**R**] key. With this image, I will crop some of the sky but my main concern is to remove the small bit of mountain peeking out in the lower left middle. The crop will aim to keep the proportion of the image where possible.

I don't think there is a need to rotate the image as it was taken on a tripod with a spirit level and just doesn't seem to be needed.

Fig. 5.3 Cropping the image.

We can make the crop and move onto the Basic panel of Develop.

One more note with the workspace setup is that I will use the Develop panels in Solo Mode, so only the one I am working on will be open.

The Histogram

This shows us that the image has a good range of tones, it was shot 'to the right' (although perhaps it could have had slightly more exposure).

There is a bit of headroom at both ends, and the image certainly could have improved contrast.

I can mouseover the histogram and manipulate the sections of it if I wish; the panel will manipulate the Blacks, Fill Light, Exposure and Recovery in the Histogram.

Again this fits into the more visual method of using Lightroom. However, we will move down the Basic Panel in order. Lightroom's layout is designed to provide a natural order of using the editing tools. Whichever order you make the changes in, Lightroom will internally apply them in the most efficient order.

The Basic Panel

First up is the White Balance tool. In this instance, I think the White Balance is just about right, so I won't be making any changes.

The image could do with a bit of warming up, but in this case it is easier to manipulate the slider to get the right level of warmth. The White Balance tool might need a few clicks to get the temperature I am after, but the slider will be quicker.

The Temperature is fine; manipulating it would make the image too Green or too Magenta.

When moving to the Exposure (and other) sliders, there are a couple of interface tricks to help us make critical decisions. In the Histogram tool are the **Clipping Warning** buttons. It is worth clicking them; any areas over-exposed will be shown in Red, and shadow clipping will be shown in Blue.

The other method is to hold down the **Option** key while you are manipulating a slider, you will be presented with a Threshold view of the clipping.

The image could do with a slight Exposure boost, and the ideal amount

Fig. 5.4 Manipulating the Histogram.

Fig. 5.5 Top: Turning on the Clipping Warning buttons;
Bottom: Clipping Warning in action.

Fig. 5.6 Threshold Clipping.

seems to be an increase of **+0.11**, so a tenth of a stop. Again this decision was arrived at visually. While the Clipping Warning will show more overexposure in the highlights, this will be in the snow-capped peak which in my view should be white!

I can still balance this with the Recovery slider, which will pull back the curve from being clipped in the highlights. I could keep playing one off against the other, but beyond a certain point I doubt I am gaining anything; in fact I may just be altering the curve too much. I end up at a Highlight Recovery of **+19**.

The **Blacks** slider is where I will want to make more of an impact. I previously mentioned that the image could do with more Contrast and compressing the Histogram in from the left is one way to achieve this.

Playing with the slider gives me a pleasing result at **+6**, which is only 1 more than the default, but you will find on some images a small amount will cause a big snap to the image.

Whereas the Exposure, Recovery, Fill Light and Blacks sliders will manipulate specific parts of the histogram curve, the Brightness and Contrast sliders will affect the whole curve. These have been likened to sledgehammer tools, but they can be used to reasonable affect. If you use the **Auto Tone** button, you will find that on most images the Brightness and Contrast are affected whereas the Recovery and Fill Light rarely are. I rarely end up using Brightness and Contrast, but in this case there is merit to increasing Brightness to **+49**.

Next up is Clarity and this will make a big difference to the midtone contrast. It is a bit like shooting in mist and then it suddenly clears, and is a great tool to use when the day is hazy. It can be overdone, so it is worth checking your image at 1:1. The Clarity slider will have the most profound affect at **+75 – +100**. In this case **+59** is enough. New to Lightroom 2 is Negative Clarity which is most useful for skin or creating a dream-like quality to an image.

Finally, adding some Vibrance to the image regains a little of the tonal values that were lost when adjusting the Blacks. I had the choice between Vibrance and Saturation, but Saturation made the image a bit too Magenta. The Vibrance tool has an inbuilt skin tone protector (skin tones are not overly saturated with the Vibrance tool) so it proves useful when dealing with the pale brown tones seen in this image.

Fig. 5.7 The Basic Panel tools applied.

Tone Curve

I am still a little concerned that the image seems to have been flattened by some of the Blacks and Recovery adjustments made, especially in the sunlit area on the midground hill. By using the **Targeted Adjustment Tool** (TAT) to manipulate the Tone Curve in that area, I can create a better balanced image.

The TAT tool will respond to the area you select. It will analyze the tones in the area under the mouse click and pick the correct part of the Tone Curve. You can use a similar tool in the HSL/Color/Saturation panel to semi-selectively amend the color balance in the image. I say semi-selectively as the change is still global, but the tool enables you to hone down to as small a range as is possible globally.

The **HSL/Color/Saturation**, **Split Tone**, **Detail** and **Vignette** panels are going to be skipped for the moment. We will visit the Detail panel later, but now is the time to look at the new Camera Profiles which were provided as a beta release with the DNG Profile Editor. We covered them in the What's New in 2? chapter and if you have them installed it is worth heading to the **Camera Calibration** panel, to see what they offer us.

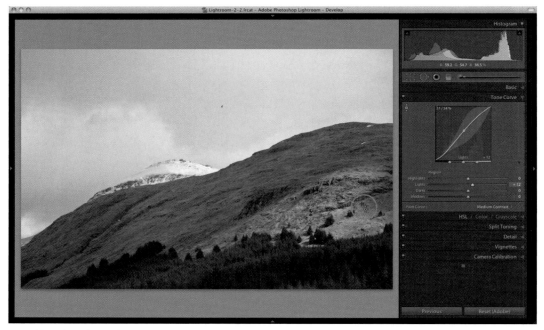

Fig. 5.8 Manipulating the Tone Curve using the TAT (highlighted). Drag the tool up to manipulate the curve upwards.

All of the corrections have so far been performed with the default ACR 4.4 profile. I can select from among 8 profiles with the Canon EOS 40D. All of them offer a distinctive difference, but the two that seem to work best for this image are the **Camera Landscape beta 1** and the **Camera Standard beta 1** profiles. Both have their merits, and the Landscape profile opens up the hillside in shadow the section, but I marginally prefer the Camera Standard profile.

Detail Panel

I now return to the Detail panel, to adjust Sharpening. There is no need for Noise Reduction or adjustment of Chromatic Aberration as this image exhibits none. The sharpening we are describing here is **Capture Sharpening**; it is designed to compensate for the inherent softness of Raw files. Most cameras have an anti-alias filter positioned between the sensor and the lens which creates this softness and coupled with the fact that Raw files have no sharpening performed in-camera (unlike JPEG files) you end up having to compensate for this.

Fig. 5.9 Left: Camera Landscape profile Right: Camera Standard profile.

These techniques were developed by Bruce Fraser and expounded upon in his book *Real World Sharpening with Adobe Photoshop CS2.*

To view the sharpening, you either need to use the Detail Selection Tool, or Zoom into 1:1 view. Once you have made the adjustments, you can use the Detail switch to view the sharpening before and after.

At any time in this process you can also use the global Before and After [\] tool to see the image in its original state, but the switches are useful for individual tools.

Fig. 5.10 Before Capture Sharpening and After.

I end up with the following Sharpening settings:
Amount: 48, **Radius:** 1.1, **Detail:** 68 and **Masking:** 35

That is all I want to achieve with the global correction tools. I will now use the Adjustment Brush to create a Localized Correction in the lower right hand area, and a Graduated Filter to make the sky more dramatic.

Adjustment Brush

I am keen to highlight the colors that are appearing in the pine forest at the bottom right of the image. At the begining of the chapter I explained that I liked the contrast between the green pine trees and the brown ones. There are lot of rich colors to be found on Scottish mountain-sides. Greens, Browns and Purples are often seen and enhancing these will bring some pleasing color to the image.

I select the Adjustment Brush [**K**], and can begin to paint a mask. For most of the area I will want a hard brush (little feather), but for the top edges I will want to soften that slightly.

As I begin to paint, it can be difficult to see the mask I am painting. Fortunately there are mask colors available to me, press [**O**] to view a mask color, press [**Shift O**] to toggle between a range of colors. Red is ideal for this purpose.

The first mask I paint is actually too big as I have gone over a transition line in the image, but no matter as I can use a soft, feathered Erase brush to reduce the mask.

Once you are happy with the Mask, hit the switch to toggle over to the Adjustment Brush detail panel. The adjustments I want

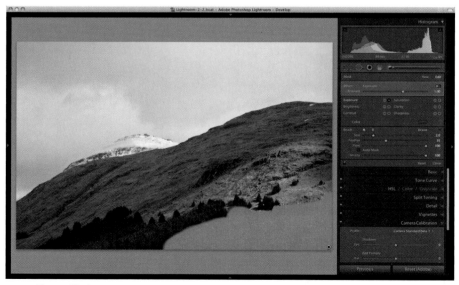

Fig. 5.11 The initial Mask.

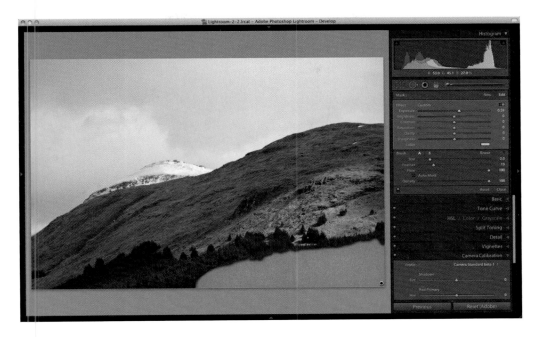

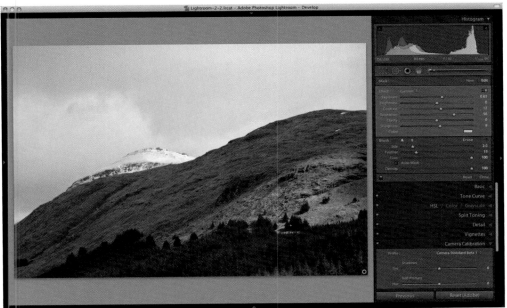

Fig. 5.12 The final Mask and the result.

to make here will bring out the color and I end up with settings of **Exposure:** +0.63, **Contrast:** +12, **Saturation:** +50 and **Sharpness:** +9 I then toggle back to the basic view and adjust the **Amount** to 50.

Graduated Filter

The last part of this Develop process is to add a Graduated Filter [**M**] to the image, to darken the sky and bring out the sparkle of the snow-capped peak.

A real-world ND Grad filter can perform one adjustment, whereas the Lightroom version of a Graduated filter can make changes to Exposure, Brightness, Contrast, Saturation, Clarity and Sharpness as well as add a Color overlay.

I want the filter to go from the top left to just below the middle at an angle. I create it and can adjust the endpoints and angle after drawing.

With the Grad in place, I can make the tonal adjustments, in this case **Exposure:** −1.35, **Brightness:** + 3 and **Clarity:** +75

I can use the [**H**] key to toggle between hiding and showing the visual outline of the Gradient, but still show the effect.

Graduated Filters

Sean McCormack of Lightroom-Blog.com has produced a kit of 70 Graduated Filters to get you started. They come in varying strengths and mimic the sorts of filters you can buy for your camera. They are available for a mere €5. **http://tinyurl.com/6zvoxn**

Fig. 5.13 The Graduated Filter applied.

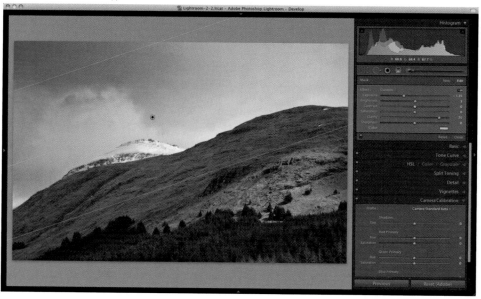

Fig. 5.14 Before and after the Develop adjustments.

Now I have completed all the development, I can use the Before and After tool [\] to show all the changes made. And shown above is the before and after of the full image.

As I am happy with what I have done, I will save the Metadata [**Cmd S**] and either revisit the image later, or move to output the image

either to Export, to the Web, to a Slideshow or to Print. We have covered the bulk of these features in the What's New in 2? chapter, but we will look at a simple print output to finish this workflow.

Printing

I now want to produce a high-quality print of the image. To get the absolute most out of the Lightroom printing capability, I would recommend that you use one of the latest Epson or Canon printers, Mac OS X 10.5 (Leopard) and have chosen your preferred output media and have had that Color Profiled.

16 bit and Mac OS X

Under certain circumstances Lightroom can output using the 16 bit drivers found in the very latest printers. You will need to visit the Printer Manufacturer's website to update your drivers. Epson, for instance, only updated some of theirs in early August 2008. You will also need to be running Mac OS X 10.5 or newer as it is currently the only operating system to support 16 bit printing. The facility was proposed for the development version of Windows Vista (called Longhorn) but was dropped for the final release and didn't appear in Vista Service Pack 1.

Lightroom's capability is more advanced than Photoshop's, which doesn't natively support 16 bit printing; it converts to 8 bit on the fly. Printing plugins such as those for Canon printers only output in 12 bits. Future versions of Photoshop are, however, likely to support a 16 bit pipeline.

According to Jeff Schewe, Photoshop and Lightroom alpha tester and consultant to Adobe:

'For "regular" photographic printing, the 16 bit pipeline really only shows any benefits on very smooth subtle gradations. It's tough to actually find images that the 16 bit can benefit over the previous printing pipeline – particularly if you allowed Lightroom to do the color handling. The reason being is that Lightroom would do the color transforms from 16 bit to the final 8 bit profiled data in 20 bit/channel precision.'

'The new 16 bit pipeline *can* pretty easily show benefits when printing "synthetic" colors and gradations out of page layout and design applications but there aren't a lot of those out there that *can* print out in 16 bit.'

But if you have the time and are concerned about the highest of quality you may want to give it a try, especially if you are producing images with subtle gradations, or skintones.

Color Profiling

Printer and Paper Manufacturers are generally kind enough to provide generic printer profiles for their papers. In recent years the Printer Manufacturers have produced better printers and supplied them with better profiles. Some, such as HP even make printers with built-in calibration. The profiles supplied are generic and won't cater for printer to printer variation, so there is a big after market in Custom Profiling printers.

Fig. 5.15 The EyeOne iSis. *Image courtesy of X-Rite.*

This can be a complex and time-consuming process but there are several do it yourself products on the market, ranging from the simple and cost-effective to the professional and expensive. You may prefer to pay for a profiling service, but if you are indecisive about your favorite paper, it can prove more cost effective to buy your own profiler.

Fig. 5.16 Left: a grayscale wedge; Right: a 1728 swatch color test chart.

The basic idea is to match your printer's output to a known target. This is achieved by printing out a file of color and greyscale swatches on a variety of paper and print settings.

The greyscale is intended to show you how well the printer can define the separation of the steps and offer a clue as to which print and paper setting is correct for your choice of media. You may find the best paper setting on the printer is not the obvious one for your choice of media!

Once you have chosen the correct media type, you then have to produce a non color-managed print of a color test chart. This test chart can consist of 225 swatches of color or as many as 1728.

You then send your money and prints off to a remote profiling company and a few days later you will be emailed a profile.

I recommend two companies to provide this service. In the US, Andrew Rodney, **http://tinyurl.com/37u2ah** and in the UK and Europe Neil Barstow, **http://tinyurl.com/6zzbpo**. Both provide an excellent service.

The profile you receive will essentially compensate for the differences between what your printer prints and what it should print.

Lightroom will use these color profiles to produce the most accurate prints possible.

Paper

There is a massive range of paper choices for inkjet printers; choosing one can be a daunting task. Most printer manufacturers produce their own range of papers which, naturally, they recommend. Some of them are very good, but you may yearn for different surfaces. I would probably use the **Epson Premium Quality Glossy Paper**, for example, were it not for the word Epson watermarked on the back of the paper!

Fortunately most paper manufacturers offer sample packs of their papers for a low cost. If you go to the websites, you will also be able to download generic profiles, so you can make a more informed decision about your choice of paper.

After several years of trying different samples I have settled on a small range. For glossy paper, I use **Harman Gloss FB Al**, **http://tinyurl.com/32hbnp,** which uses the new Baryta substrate, which seems to give results that are closer to traditional darkroom glossy papers. For a smooth Matt paper I use **Harman Matt FB Mp, http://tinyurl.com/32hbnp,** and for art Matt paper I either use **Hahnemüle Photo Rag**, **http://tinyurl.com/6dp55g** or **Crane's Museo AM**, **http://tinyurl.com/5mtbdm**. They all give a really high quality feel and produce excellent prints. But your choice will probably be completely different.

All of these papers have been custom profiled; you can really tell the difference between generic profiles and custom if you produce comparative prints. The custom profiled print will not only be more color accurate, but you will probably find a lot more detail is shown.

Lightroom Printing

If you are used to a Photoshop-based workflow, you will probably be used to printing one image at a time. This is a bit frustrating if you have a deadline and need to get a batch of prints out. Lightroom is designed to batch print. You can still produce one-offs, but being able to produce hundreds of identically set-up prints will be a real benefit to the hard-pressed wedding photographer.

With Lightroom 2 we can also create Picture Packages as we saw in the What's New in 2? chapter.

But the ability to create compelling, high-quality prints with a variety of effects is what sets Lightroom apart from Photoshop.

Fig. 5.17 The default print layout.

With our workflow image we will produce a print to show the setup of printing. There are some caveats to be aware of. I am showing this on a Mac, so your interface may be different and I am using an Epson printer, so the screenshots you see may differ.

We are going to set up a Fine Art Print, using the **Layout Engine** with **Contact Sheet/Grid** as the option.

The screen above shows the default page, so we need to make some adjustments to the settings. Firstly we will turn **Rotate to Fit** off, so that we will print a landscape image on a portrait print.

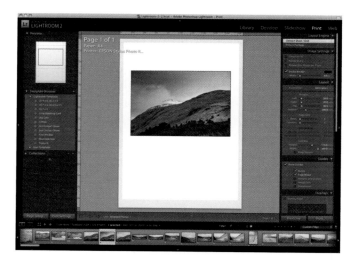

Fig. 5.18 Setting up the Fine Art Print.

Fig. 5.19 Choosing Solo Mode.

As it is a Fine Art style print, we will want to add some margins as well, so in the Layout panel we will make these adjustments, **Left** and **Right:** 20 mm, **Top:** 30 mm and **Bottom:** 100 mm.

If you were printing for a more commercial reason, you might want to use some of the Overlays to include your Identity Plate or some of the Photo Info you are able to apply.

I would like this print to have a 0.5pt Stroke Border as well which I will set in the **Image Settings** panel.

Now the important settings to change are in the Print Job Panel, so I would right-click the Print Job title and select **Solo Mode**; this closes all the panels apart from Print Job.

For the particular paper I want to print on, Harman Matte, I will set the following settings: we will want to print to **Printer** at **300ppi**, with Print Sharpening set to **Standard** and **Matte**. We will leave 16 Bit Output switched on, whether it is used or not.

In the Color Management section, the default will be **Managed by Printer**. Now we won't want this as it won't allow us to choose our Custom Profile. We will therefore choose **Other...** from the Profile menu.

This shows a dialog box so we can choose from our list of Profiles. For this print we will choose, **RE-HarmanMatt.icc** and **rich_museo-archival_matt_2.icc**. Press **OK**, and we will now be able to select the RE-Harman Matt.icc profile from the Profile menu.

The correct **Rendering Intent** depends on the image, but in this case Relative will give the image a slightly milky appearance, so Perceptualw is the right choice.

Print Profiling

While Print Profiling isn't an option in Lightroom, you can give yourself an idea of how the image will print by selecting **Print to JPEG**. This allows you to produce a file to view, you will be able to make judgements on quality, print sharpening and rendering intent. We have mentioned elsewhere that judging Print Sharpening is very difficult as it will always look over-sharpened. Examples of this are shown overleaf.

We can also use this to produce a file which shows the full layout of the print.

But our main intention is to produce a print, so while we can use this to fake Print Profiling, we may still have to produce one or more test prints to ensure that the final output is what we require.

Fig. 5.20 Rejecting Managed by Printer.

Fig. 5.21 Selecting Profiles.

Fig. 5.22 Print to JPEG, a method of Print Profiling.

Fig. 5.23 A comparison of Low Print Sharpening (top) and High Print Sharpening (bottom) produced using the Print to JPEG facility.

Fig. 5.24 The full Print to JPEG file.

Print Setup

Swap back to **Print to Printer** and we can begin the setup process. Select **Page Setup** and ensure that your printer is set up for the correct paper.

Press OK, and move on to **Print Setting…**. This sets up the printer for the specific paper choice and quality settings.

Having made all our print settings, it will be very useful to save this as a Preset. We talk more about Presets in the next chapter, but what is extra functionality with Print Presets is that all the choices are included (including the Print Dialog box settings). Saving a Preset means we can reuse this style and paper setting in the future and in effect create a really simple printing process; select Preset, press Print!

Add the Preset and give it a useful name so you will be able to remember what you set in the future. In this case **Harman Matt-Fine Art-Portrait**.

Fig. 5.25 The default print layout.

As we are producing an individual print, we can just select **Print One**, and the file will be printed.

If you are likely to produce similar prints with different profiles, it is worth setting up several Print Templates with all the variations. This makes printing in Lightroom a fast and simple process.

Recapping this chapter, we have taken an image through the Develop process all the way to print output. We have shown some of the workflow and new options available in Lightroom 2 and shown how to set up printing to be a two-click process.

Next we look at how Presets will help in all areas of Lightroom to save common settings for reuse.

Fig. 5.26 Setting up the Fine Art Print.

Lightroom Presets

Lightroom's ability to save and distribute presets is both highly useful and has proven to be immensely popular. Yet conversely the full power and scope of Lightroom's Presets remain a relatively hidden feature of the application.

What are Presets?

Simply, they are a file of settings that can be saved for applying similar effects on a repeated basis.

Lightroom 2 allows presets to be saved throughout the application, including for: Develop, Export, Filenaming, FTP, Keywords, Labels, Localized Corrections, Metadata, Printing, Slideshows, Text and Web.

Let's look at some of these and how they can be used to best effect and speed up your workflow.

Develop Presets

The most popular presets throughout the Public Beta of v1.0 and the full release of v1.0 have been Develop Presets. The facility to save and distribute these was first brought to the attention of the Public Beta users of v1.0 by Sean McCormack. I then set up a website <http://inside-lightroom.com> to act as a repository for those that were created, and since then there have been numerous contributions from Lightroom users all over the world and many other sites create and share them.

Develop Presets offer a snapshot of a particular look that the user has created and thereby the facility to apply this look to many files. They can be used to apply simple color looks to an image, they can be used to standardize color calibration and they can apply special effects, including cross processing, black and white, and even negative effects to images.

Presets can be found in the following folders:

Mac: `~/Library/Application Support/Adobe/Lightroom/`
XP: `C:\Documents and Settings\<username>\`
`Application Data\Adobe\Lightroom\`
Vista: `/AppData/Roaming/Adobe/Lightroom/`

With the various types of Presets viewable in further subfolders.

They can be viewed in a text editor but they are actually Lua script files. Whereas Lightroom's counterpart Adobe Camera Raw stores such settings as XMP data, presets in Lightroom have more of a programmer's procedural syntax. We'll look at these in more detail later, but for now we will concentrate on basic use cases.

A First Preset

There are a number of places where Develop Presets can be applied in Lightroom, but let us start with the most obvious; the Develop Module.

Let's assume that your camera shoots quite soft images that would benefit from a little extra punch. Without presets you would open an image in the Develop Module, adjust the Exposure, and the Blacks and boost the Clarity. If this is something you have to do for each image it would be very time

Lua

Lua is a powerful, lightweight embedded scripting language that Lightroom incorporates. While conventional programming languages are used to create the program, Lua has been integrated in order to assist with scripting and output. More information about Lua can be found at **http://www.lua.org/**. There is a two part interview with Mark Hamburg which explains some of the uses of Lua in Lightroom. Troy Gaul, Lightroom project lead, recently gave a talk at the Mac-dev C4 conference where he took a look at the structure of Lightroom.

http://tinyurl.com/6pjv7o
http://tinyurl.com/2×8aaa
http://tinyurl.com/665cco

Fig. 6.1 The Develop Module with some Adjustments made.

consuming. Since Lightroom is a workflow application, it offers the ability to save these settings as a preset.

In Figure 6.1 we see the Lightroom interface with adjustments made in the right panel. In the left panel, we see the Presets section. Adobe have provided a few starter presets, but we will now create a 'User Preset'.

Click on the + button in the Presets header and the following dialog opens, Fig. 6.2.

From here you have some choices. First, name your preset, in this case **More Punch**. Then you have the option to select which parts of the Develop Module settings you wish to include in the Preset.

Why would you choose only a sub-section of the settings? Well if in this example we saved all of the settings in our preset and then did the same with another, similarly saved, preset which made other color or tone settings, the second would cancel out adjustments in the first.

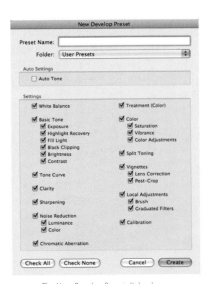

Fig. 6.2 The New Develop Preset dialog box.

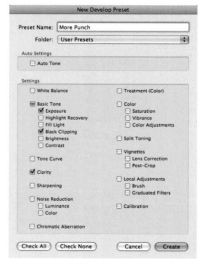

By saving a sub-section, you are offering the opportunity to save cumulative presets. So **More Punch** might adjust the Exposure, Blacks, and Clarity. Another preset might adjust the Tone Curve and Split Tone the image. You would be able to apply both without them affecting each other.

So back to **More Punch**. In this case it is worth saving a sub-section. By default on creation of a new Develop Preset all the check boxes are checked but as we are only going to be selecting a small number of the check boxes, press the **Check None** button, then in the Basic Tone section select **Exposure**, **Black Clipping** and **Clarity**. Then press **Create**. In the User Presets, section of the Presets panel we now have our **More Punch** preset. If we now select another image and click on the **More Punch** name that image will have the same settings applied.

Applying Presets to Many Images

Fig. 6.3 Creating the More Punch Preset.

You can apply these settings in other ways. If we swap back to the Library Module's Grid Mode **[G]** and Select All of the images **[Cmd A]** you can adjust all of the images to have the **More Punch** preset.

Fig. 6.4 Applying the More Punch Preset to a selection of images in the Quick Development Pane.

Look at the first item in the Quick Develop panel on the right. There is a pull down list called **Saved Preset** (and it will probably

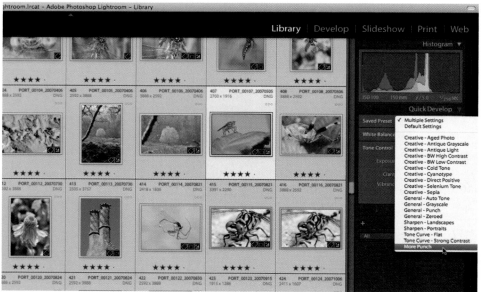

say Multiple Settings), if we select **More Punch** from that list, all of the images will now be affected and the images will updated.

If you are shooting many thousands of images, and perhaps they all have the same fault, then this method of normalizing all of your images will be very speedy.

However, it doesn't end there. When you import images you are similarly offered the chance to apply presets.

To see this in action, simply Import a new batch of images. Press the **Import...** button **[Cmd-Shift-I]** and choose some images to import. The Import Photos dialog box will open. At the bottom of this in the **Information to Apply** section, is a pull-down menu **Develop Setting**. From this select **More Punch** and press the Import button.

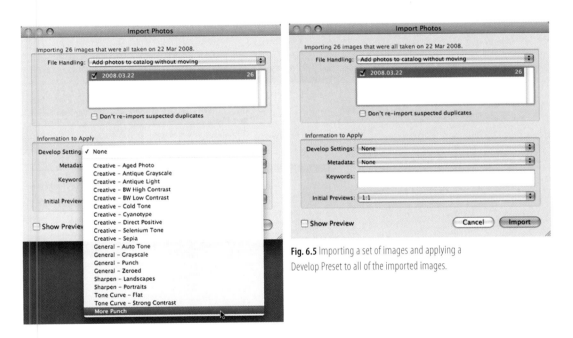

Fig. 6.5 Importing a set of images and applying a Develop Preset to all of the imported images.

As you might expect this will apply the Basic adjustment to all of the imported images. Another time saver.

If we go back to the Develop Module **[D]** there is another way to apply the preset to many images. With an image on screen where

Fig. 6.6 Applying the settings of the previously adjusted image to the next selected image.

you have applied the **More Punch** preset, move to the next image **[right-arrow key]**, press the **Previous** button, at the bottom of the Develop module, this will apply the settings of the Previous image to the next one. This will also apply to the next selected image (which may not be the next in sequence).

If you have many images in the Filmstrip that you wish to apply the settings of the **More Punch** preset to, you can also **Sync** them with the first image to which your preset has been applied.

Again in the Develop Module, select the original image to which you applied the preset, then scroll through the Filmstrip and select the other images you want to apply this preset to. The assumption with this method is that you will want to apply the preset to a non-contiguous selection of images, in which case select them using the **[Cmd]** key.

Fig. 6.7 Selecting Sync. . . .

Then when you have made your choice, press the **Sync...** button. Up pops the **Synchronize Settings** dialog box. The previously checked items (making up the **More Punch** preset) will be selected. Click Synchronize and the subsequent images will have their settings synchronized with the first selected. Note that the crucial action when performing the Sync command is which image you select first, it has to be the one to which the Preset has been applied. If you make a mistake there is always Undo!

Fig. 6.8 The Synchronize Settings dialog box.

There are other modes to the Sync… button. Pressing the Option key turns the button into Sync and will Synchronize settings without the dialog box appearing. Pressing the Command key will turn the button into **Auto Sync**, which as the name applies automatically synchronizes the selected images (as you select them) with the first image.

Fig. 6.9 The three modes of the Sync button, from left to right: Sync…, Sync (hold down the Option key) and Auto Sync (hold down the Command key).

Naturally a bit of care is needed when choosing the other two options, it is much easier to make mistakes. So 'Think before you Sync!'

Changing Lightroom's Defaults

A final method of Develop Preset application is to use the preset as the application's default setting for the camera. This is most useful if your camera(s) displays a consistent trait, or if you have performed a calibration in a control lit environment.

Lightroom and Adobe's Camera Raw both support the facility to save defaults on a camera model, serial number and/or ISO basis. With the previous methods of applying presets, to be more selective about their application you would have to filter your images using the Metadata Library Filter to get this level of granularity. By setting new defaults, time and effort can be saved.

Open Lightroom's preferences **[Cmd-,]** and select the Presets tab.

Fig. 6.10 The Lightroom Preferences dialog box, with the Presets tab selected. The red box shows the section devoted to setting defaults.

The defaults highlighted in Fig. 6.10 apply to specific camera models (by serial number) but will disregard the ISO rating of your images. If your camera exhibits more noise at higher ISO levels or, if you have a batch of cameras of the same model this might prove unsatisfactory.

If we go back to our adjusted image in the Develop module, hold down the Option key and we can see that the Reset button which was next to Previous has now become **Set Default…**.

Press the button and a dialog box will open offering you the chance to 'Change the default settings used by Lightroom and Camera Raw for negative files with the following properties'.

Depending on the checkboxes you tick in the Preferences dialog you will be offered the following options.

Here the selection is **Make defaults specific to camera serial number**. So any image taken by the Canon EOS 400D with the serial number 0000000000 will have the **More Punch** preset settings set as the default settings.

With this Preference setting (neither checkbox selected) the defaults will now apply to the model of camera. So images from all Canon EOS 400D you might own (or whose images you may be using) will have the **More Punch** preset settings applied by default.

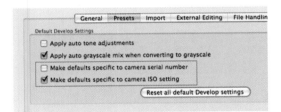
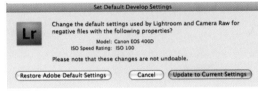

The third Preference setting is to check **Make defaults specific to camera ISO setting**. This will set the defaults for any image taken by a Canon EOS 400D at ISO 100 to **More Punch**.

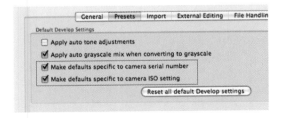
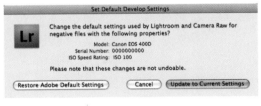

Finally checking both boxes, **Make defaults specific to camera serial number** and **Make defaults specific to camera ISO setting** will set the defaults for an image taken by a Canon EOS 400D with the serial number of 0000000000 at ISO 100 to **More Punch**.

Where this becomes useful is if you found that this combination of Exposure, Black Clipping and Clarity was less effective on an image shot at ISO 800. Using these Set Default preferences you can create a specific case where you apply a different adjustment to your ISO 800 image, then perhaps added some Noise Reduction. Here is a walkthrough of how to do this.

Select your ISO 800 image in the Library [L], then enter the Develop Module [D].

1:1 Detail Panel

New in Lightroom 2 is the 1:1 preview in the Detail pane, it allows you to view the detail in your chosen area, however for this purpose it is too small an area.

Open the Preferences and select the two checkboxes, then close the Preferences.

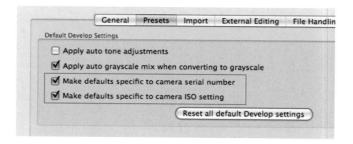

Make your changes to the image. In this example, I am happy with the Exposure, Black Clipping that More Punch offers, but the Clarity isn't quite enough (as the higher ISO has made the image softer) and I would like some Noise Reduction. So on the image, I select the More Punch preset and then open the Detail panel on the right of the Develop Module.

Zoom into 1:1 or 2:1 view on the image, so that the Noise Reduction settings can be viewed across the whole image.

As can be seen from the figure above, the noise levels are pretty acceptable for an ISO 800 image (as is true with most recent DSLRs). However, adjusting the controls in the Detail panel will lower this further.

Playing with the two Noise Reduction settings I can see that adjusting the Color Noise Reduction has little if any effect, whereas

Luminance Noise Reduction will clean up the background speckling very cleanly. By boosting it to 100, the background looks clean, without loss of detail in the rest of the image. It is worth panning around the image to check you are happy with all the areas. One smart way to achieve this is to press the **Home** key on your keyboard and then press **Page Down**. Lightroom scrolls until the end of the 'column' and then moves to the next 'column'.

Next save the Preset. Click the + button on the Preset panel, **Exposure**, **Black Clipping** and **Clarity** will already be selected, now check the **Luminance Noise Reduction** box and name this preset, **More Punch ISO 800**.

Set Default Develop Settings

Lr

Change the default settings used by Lightroom and Camera Raw for negative files with the following properties?

Model: Canon EOS 400D
Serial Number: 0000000000
ISO Speed Rating: ISO 100

Please note that these changes are not undoable.

Restore Adobe Default Settings Cancel Update to Current Settings

Now in the bottom right of the Develop Module, press Option and Set Default... and up will pop the Set Default Develop Settings dialog box. Press **Update to Current Settings** and this will set the default by camera model, serial number and ISO.

All newly imported images from this camera at ISO 800 will have these settings applied, but for legacy images there are a few more steps to apply.

In the Library Module **[G]**, open the Metadata Library Filter pane **[\]**, select Browse. In the header of the first two columns select Camera and ISO Speed, then select the camera (in this case the Canon EOS 40D) and the ISO Speed (800). Press Cmd-A to select all, then move to the Develop Module.

In the Filmstrip select the first image, then apply the **More Punch ISO 800** preset, then Shift Select the last image in the Filmstrip (this should select all of the images in the Filmstrip).

Then press the **Sync...** button, the Synchronize Settings dialog box will open, this will have the Exposure, Black Clipping, Clarity and Luminance Noise Reduction boxes checked. Then press **Synchronize**.

Develop Preset Possibilities

Having seen all the methods of applying Develop Presets, we can look at some of the possible effects that can be applied. Starting with a base image, I can apply presets to images to give them a new look. These presets are all available from the Inside Lightroom **http://www.inside-lightroom.com** site and show the basis of what is possible.

The range of possible effects tend to be broken into Color; attempts to provide color 'looks' or mimic film, Black and White; mimicking old processes or film styles, Cross Process looks and Split Tone effects. There are a number of presets that deal with Camera Calibration as well.

In all cases these are just one person's interpretation and can be used as the basis for refinement. I always caution that the presets provided by Inside Lightroom and everyone else are just starting

Fig. 6.11 A range of Develop Presets.
Top Row: Original Image, Hanne Split Tone – Andrew Stawartz, 300 – Mike Lao.
Middle Row: Chocolate B + W – Kasandra Atwood, Dragan 6 – Sean McCormack, Cool Bluetone – Ian Lyons.
Bottom Row: Faded Elegance – Richard Earney, Cross Process – Alan Miller, Hamburg's Funky Twist – Mark Hamburg.

points. Each image will react in different ways to the settings applied. The fun is seeing what is possible!

Later we will look at more extreme subversion methods using outside editing and tools.

Inside a Preset

If we take a look into a preset, we will begin to see how simple they can be and how complex they can get, and discover further possibilities.

Firstly open up the **More Punch** preset in a text editor, TextEdit on a Mac or Notepad on Windows and we can have a look at its component parts.

If we look at this in order, each Preset is assigned an **ID** and a **Unique User ID** (uuid) to stop duplicates occuring, as well as having an **Internal Name** a **Title** and it also gets a **Type** which in this case is Develop.

```
● ● ●          More Punch.lrtemplate
⌐ = {
      id = "3959FA2F-A52D-4D0A-A5C8-93C80929BFFB",
      internalName = "More Punch",
      title = "More Punch",
      type = "Develop",
      value = {
            settings = {
                  AutoExposure = false,
                  AutoShadows = false,
                  Clarity = 35,
                  Exposure = 0.25,
                  Shadows = 8,
            },
            uuid = "75DD031A-B71D-41E5-8076-64F21B6F5BF7",
      },
      version = 0,
}
```

```
● ● ●          More Punch ISO 800.lrtemplate
s = {
      id = "C2A659A4-66BE-4AF4-A67D-72AFADB7207A",
      internalName = "More Punch ISO 800",
      title = "More Punch ISO 800",
      type = "Develop",
      value = {
            settings = {
                  AutoExposure = false,
                  AutoShadows = false,
                  Clarity = 40,
                  EnableDetail = true,
                  Exposure = 0.25,
                  LuminanceSmoothing = 100,
                  Shadows = 8,
            },
            uuid = "1C4FEA99-8F77-4773-BB47-CFCBC08E3516",
      },
      version = 0,
}
```

Fig. 6.12 The **More Punch** and **More Punch ISO 800** presets viewed in a text editor.

The most important parts of the preset are the section that comes under '**settings**'. The user can set Exposure and Shadows to an Auto value as determined by Lightroom, we did not do that in this preset so **Auto** is set to false. **Clarity** has been set to **35**, **Exposure** to **0.25** and **Shadows** (Black Clipping) to **8**.

If we compare this with the **More Punch 800 ISO** preset, we can see the change in **Clarity** to **40**.

Fig. 6.13 The 'Enable Detail' switch.

This time we have enabled the **Detail** setting, in this case **Luminance Smoothing** to **100**. Luminance Smoothing is the same as Luminance Noise Reduction; some of the names in the preset file are different to the names used in the interface. This is partly because the names in the user interface have changed from the first public betas of v1.0 but the functionality hasn't.

Editing this text file allows us to change the functionality of a preset.

Radical Presetting!

Editing presets by hand or even in Adobe Camera Raw allows you to break out of some of Lightroom's shackles. The shackles occur in the Tone Curve panel. Lightroom only allows Parametric Curve editing – this restricts you to what is considered optimal

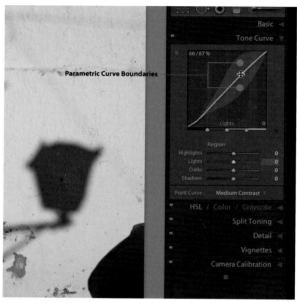

within an image, but doesn't allow for more creative effects such as Solarization or even Negative curves.

Adobe Camera Raw allows for Point Curve editing and the curves will transfer over to Lightroom. Editing a preset in a text editor will allow similar possibilities, however you have to be careful not to miss out any piece of the preset's syntax as this can render the Develop Module inoperable! Removing the offending preset or correcting the error and restarting Lightroom will restore the application to normal working order.

Here are a couple of examples of what is possible.

If we look at an image with Lightroom's Tone Curve panel open, we can see the limitations of Parametric Curves.

Fig. 6.14 The 'Parametric Curve limits of Lightroom's Tone Curve panel.

Fig. 6.15 Parametric Curve preset.

In each of the sections, Highlights, Lights, Darks and Shadows the Tone Curve cannot be moved beyond the edge of the light grey boundaries.

Save a quick preset of just the Tone Curve for later use.

If you have Photoshop and Adobe Camera Raw (ACR), open the image and see what can be done in ACR.

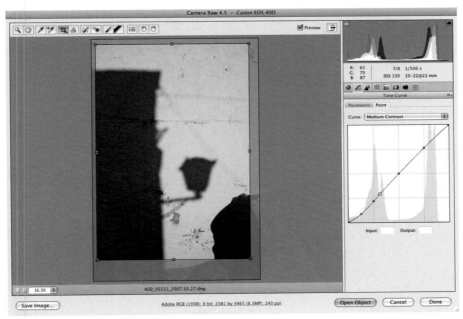

Fig. 6.16 The same image open in Adobe Camera Raw.

Here we have opened the image and moved to the Tone Curve panel and the Point Curve tab. This gives us much finer control over the curve than Lightroom's parametric curve.

Now make a more radical tone curve, to create an 'M' curve. Then press **Done**.

Return back to Lightroom. In the Library module select from the menu **Metadata** > **Read Metadata from File**. The Preview in the Library should now change to something like the wilder manipulation from ACR.

Select the image and move to the Develop module, you will immediately see that the Tone Curve replicates that of ACR. It is

155

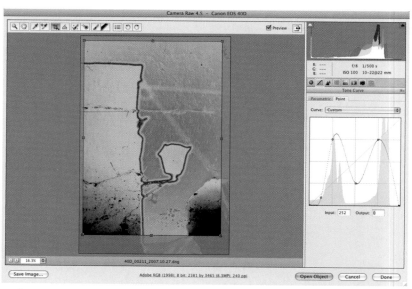

Fig. 6.17 The 'M' Curve in Adobe Camera Raw.

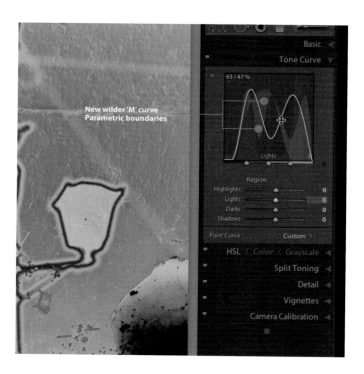

Fig. 6.18 The same 'M' Curve in Lightroom.

still parametrically restricted, but the restrictions are sympathetic with the new more radical Tone Curve.

Negative Presets

A more common curve is a negative Tone Curve, which can be used on scans of Color or Black and White negative files.

We can achieve this in ACR by manipulating the 0 point to be 255 and the 255 to be 0, but for this we will edit the preset in a text editor.

Open up the saved Preset, **Parametric Curve**, that we created before going into ACR in your text editor.

```
● ● ●        🔲 Parametric Curve.lrtemplate
$ = {
        id = "4B8E355E-3139-487B-8395-DE7AAF745CF2",
        internalName = "Parametric Curve",
        title = "Parametric Curve",
        type = "Develop",
        value = {
                settings = {
                        ParametricDarks = 0,
                        ParametricHighlightSplit = 75,
                        ParametricHighlights = 0,
                        ParametricLights = 0,
                        ParametricMidtoneSplit = 50,
                        ParametricShadowSplit = 25,
                        ParametricShadows = 0,
                        ToneCurve = {
                                0,
                                0,
                                255,
                                255,
                        },
                        ToneCurveName = "Linear",
                },
                uuid = "13D9174E-B6D6-4D47-A310-B13FFF623F4B",
        },
        version = 0,
}
```

Fig. 6.19 The 'M' Curve displayed in Lua text.

The section we are interested in is the Tone Curve numbers. They are simply denoting that 0 should be reproduced as 0 and what is 255 should be reproduced as 255.

Edit the numbers to be 0, 255 and 255, 0, change the ToneCurveName, internalName and title to be Negative Curve and then save the preset as Negative Curve. Quit Lightroom and then restart.

From the Presets panel, select the Negative Curve. The image will now be in negative with Tone Curve adjustments available parametrically along the negative path!

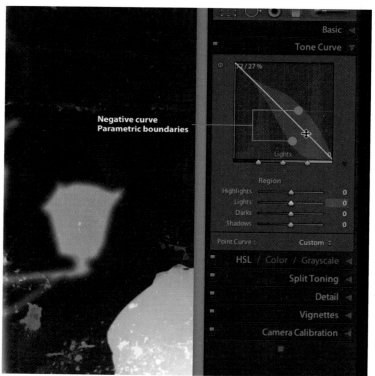

```
s = {
        id = "4B8E355E-3139-487B-8395-DE7AAF745CF2",
        internalName = "Negative Curve",
        title = "Negative Curve",
        type = "Develop",
        value = {
                settings = {
                        ParametricDarks = 0,
                        ParametricHighlightSplit = 75,
                        ParametricHighlights = 0,
                        ParametricLights = 0,
                        ParametricMidtoneSplit = 50,
                        ParametricShadowSplit = 25,
                        ParametricShadows = 0,
                        ToneCurve = {
                                0,
                                255,
                                255,
                                0,
                        },
                        ToneCurveName = "Negative",
                },
                uuid = "13D9174E-B6D6-4D47-A310-B13FFF623F4B",
        },
        version = 0,
}
```

Fig. 6.20 Editing the preset file to create a Negative Curve.

Negative curve
Parametric boundaries

Fig. 6.21 The same Negative Curve in Lightroom.

Local Corrections

With Lightroom 2 users can locally adjust sections of an image. These Local Corrections can still be saved as presets, which may be useful if you have several images shot in the studio, but applying these presets to many images is less likely. The presets are also much more complex files, and editing them becomes a much harder task. Just a small amount of a Brush Local Correction can lead to a file with many hundreds of lines.

Localized Adjustment Presets

Another variety of Local Correction presets are the ability to save your specific Localized Adjustments as a reusable setting. With both the Adjustment Brush and the Graduated Filter you can create presets to store your frequently used adjustments. One example included with Lightroom is Soften Skin which is very useful for portrait retouching work.

It adjusts the settings as follows:

$$exposure = 0,$$
$$saturation = 0,$$
$$toningHue = 240,$$
$$toningLuminance = 0,$$
$$toningSaturation = 0,$$
$$clarity = -1,$$
$$sharpness = 0.25,$$

```
                            Local Correction.lrtemplate
  ▶ = {
      id = "CD59F86A-8C85-4AA0-831C-C27267E9C77C",
      internalName = "Local Correction",
      title = "Local Correction",
      type = "Develop",
      value = {
          settings = {
              EnablePointBasedCorrections = true,
              PointBasedCorrections = {
                  {
                      CorrectionActive = true,
                      CorrectionAmount = 1,
                      CorrectionID = "8D62B25F-4356-44CA-90A5-C52803E9BF3C",
                      CorrectionMasks = {
                          {
                              CenterWeight = 0.199535,
                              Dabs = {
```

Fig. 6.22 A small portion of a Local Correction adjustment.

Filenaming Presets

Having looked at Develop Presets in some depth, it is worth concentrating on a few of the other sorts of presets. The file renaming facility in Lightroom is pretty comprehensive, there aren't many possibilities that are not covered.

One area that isn't, is very long numbering systems. As photographers shoot more and more digital images, so the naming structure becomes important.

My naming structure is as follows.

40D_00000_2008.02.15.dng

Where 40D is the model number, 00000 is a five digit serial number and 2008.02.15 is the date taken. This has been fine so far because I have never shot over 99 999 images on a camera type.

But if I wanted to have more than 5 digits what could I do since Lightroom only allows 5 digits in its numbering sequence? There are two approaches one is manual and the other is to edit the preset.

With the first we could add a static 0 in front of the 5 digit number, but when we came to 100 000 we would have to edit the File Name Preset to add a 1.

Fig. 6.23 Using tokens to edit the Filename Template.

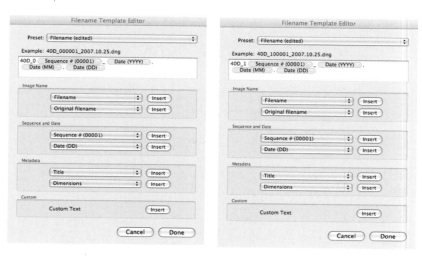

Fig. 6.24 Manually editing the Filename Template Editor.

This wouldn't be ideal, but using a text editor we can overcome this limitation.

If we save this file name preset as Test and open it in a text editor (it will be in a folder above the Develop Presets area called Filename Templates).

Here we see the values that have gone to make the naming template. If we edit the line saying:

```
value = "naming_sequenceNumber_5Digits",
```
to read:
```
value = "naming_sequenceNumber_6Digits",
```

then save and use this template, Lightroom will automatically roll the numbering system to beyond 99 999 and there will be no need for manual intervention.

You can actually change the token to be:

```
value = "naming_sequenceNumber_9Digits",
```

to give you numbers up to 999 999 999. After that you really will have to add your own, but hopefully 9 digits will be enough to go along with!!!!

Print Presets

Print Presets can be even more useful as they can save all of the printer and page settings as well allowing you to produce perfect prints for hundreds of prints at a time (ink permitting!).

The important step is to set up all the correct settings before saving a Preset. In this example we are going to create a 'Fine Art Style' print that will print on to Harman Gloss paper, in 16 bit mode at 300 ppi with High Print Sharpening.

Note that the facility to print in 16 bit mode is new to Lightroom 2 as is Print Sharpening which is based on the PixelGenius Photokit Sharpener plugin for Photoshop. As is Lightroom's way it has simplified the options so that only the ones you need are visible. So whereas there are numerous settings in the Photokit Sharpener plugin for Photoshop; in Lightroom 2 it is Low, Medium and High and you don't get to see what output sharpening looks like (unless you print to a JPEG file).

The rationale being that the human eye would think that the image was oversharpened whereas for an inkjet or other printer that level of sharpening would be perfect. However it might entail 3 prints just to see what the effect of each setting has on

Pixel Genius

PixelGenius are a group of industry experts who have created PhotoKit software over the past seven years. Their membership includes Jeff Schewe, Martin Evening, Seth Resnick, Andrew Rodney and Mac Holbert. The late Bruce Fraser was a member until his death; it was his knowledge of color management and sharpening that drove some of the features available in Lightroom. He and Jeff Schewe both consulted with Adobe over the best way to implement sharpening.

http://tinyurl.com/3yy9dk

Fig. 6.25 Left: Unsharpened image in Lightroom. Output Sharpened image for Print.

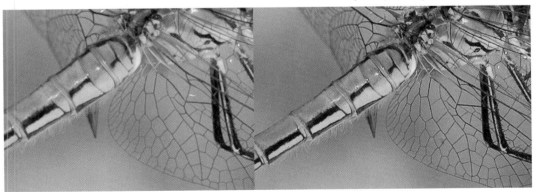

an image! So far in tests I have found that the Print Sharpening works exceptionally well. You have options for Matte and Gloss paper and these will work for other output media including prints from Photo Labs.

Note that you can also sharpen an image in the Export module where you have the choice of sharpening for Screen as well.

Setting up a Print Preset

In this example I have set the print up to have 'fine art' positioning on the page and I have then set the Print Job to go to the printer at 300 ppi, with High sharpening suitable for Gloss paper via the 16 bit driver using a custom profile called RE-HarmanGloss.icc with a Perceptual rendering intent.

Set the printer up as well. Press Page Setup…. In my case using an Epson Stylus Photo R2400 I will choose the setting as shown in the following screens.

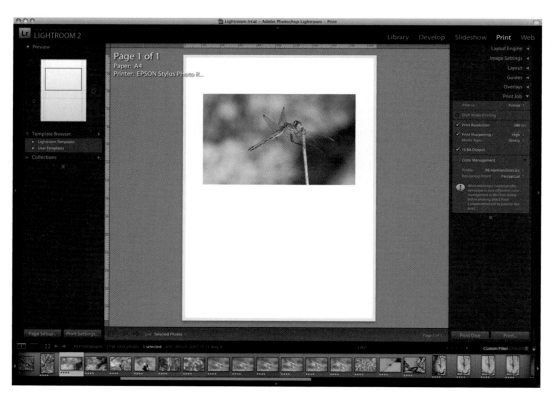

Press OK, then choose Print Settings.... This is the normal Print dialog box, but the aim is to choose settings to be saved, rather than immediately make a print.

Now all the settings have been made, press Save. All of these choices are saved for this instance but not for reuse. So in the Template Browser, click the + sign to add a Print Preset and it makes sense to give it a reasonably descriptive name.

All of the settings will now be embedded in the Preset, so to reproduce that print style again will simply be a matter of selecting the preset, and pressing the Print One button. Holding down the Option key will bypass any Print dialogs, so you can simply, select the images to print, enter the Print Module, select a Preset and Option Print and they will immediately be sent to the Printer. See the previous chapter for the full Develop workflow including Printing.

Fig. 6.26 The various Print Settings screens. **Top Left:** Layout, which has been set to 1 page per sheet. **Bottom Left:** Color Matching will be greyed out because we have set Lightroom to manage the Color Matching. **Right:** The 'Basic' print settings which are choosing the best quality for Gloss Paper.

Fig. 6.27 Saving the Template.

Other Presets

In this section we will cover some other useful presets that Lightroom offers.

Fig. 6.28 The External Editing section of the Preferences dialog.

The first is new to v2.0 and it allows you to set up multiple external editors for your images. Previously in v1.x you had a choice of two editors only. The first is usually your default version of Photoshop, in this case CS3. This can vary depending on your default image editor. Now we can set up a few more.

Open **Lightroom** > **Preferences** and choose the External Editing tab. In the Additional External Editor section, choose an Application. I will set up two external editors in this example, Photomatix Pro and Helicon Focus. The former is for creation of HDR images and the latter for Focus Stacking.

Click the **Choose** button and navigate to Photomatix Pro's location and select it. Then choose the File Format settings. Here I have chosen **File Format:** PSD, **Color Space:** ProPhoto RGB at 16 bit and a resolution of 240 ppi.

Then in the Preset pull-down menu choose Save Current Settings as New Preset…. In the resulting dialog box I called the setting Photomatic Pro.

Then repeat this for Helicon Focus, and you will have a second External Editor to choose from.

Back in the Library Module when we right-click to choose the External Editor, the applications chosen will appear in the menu.

Fig. 6.29 Creating External Editor presets.

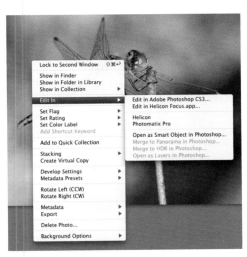

Fig. 6.30 Choosing an External Editor.

Web Module Presets

Over in the Web Module, there are two sorts of Presets, Web Templates and FTP settings.

Web Templates normally come with Web Engines. There are various Web Engines supplied with Lightroom, those created by Adobe and those created by Airtight. There are also several sites devoted to Web Galleries (see the Resources chapter) and generally a Web Engine/Gallery will come with one or more default variations

(aka Templates). If you set up your own variations of these Templates, then you can save them as your own User Presets for easy recall.

This proves an easy way to add your own personality to a third-party gallery that many others might use.

FTP Presets

In the Web Module you can also save your server locations for easy site upload. This facility is found in the Upload Settings of the Web Module.

Click on Custom Settings to begin editing, and in the resulting dialog box, enter the particular configuration for your FTP server, and ensure you save it as a Preset. This will allow more than one FTP server to be set up, so you can post galleries to multiple places.

The other way to export images to a website such as Flickr, SmugMug and Zenfolio is to use Export plugins. These are covered later, but suffice to say you are also able to setup presets with these Export plugins to enable a consistent approach to creating a set of images for posting.

Slideshow Module Presets

Having been through several of the other module's presets, it will come as little surprise to see that the Slideshow module has them. As usual, setup your preferred settings for a Slideshow and when you are happy, save a preset.

Library Module Presets

We have already touched on Renaming Presets, but the Library also caters for a few other kinds of Preset. Metadata Presets, Keyword Presets and Export Presets.

Metadata Presets

These are used in the main window of the Library, but can also be called on import. Metadata Presets are most useful for applying global metadata settings to all your images; adding copyright, date and photographer info, etc. If you work in a busy studio

with several photographers, it will be useful to create Metadata Presets for all the photographers.

In the Metadata pane of the Library Module find the Preset section (near the top) and select **Edit Presets…**.

You will then see the Edit Metadata Presets window. The areas most usual to fill in are shown in figure above in the unfurled sections. Remember that these are *global* metadata settings, so it is less likely that you will be applying the Rating to the image, for example, but you will probably add copyright and creator information.

Before pressing **Done**, be sure to save the Preset with a meaningful name.

You can apply this Metadata Preset in the Library Module, by applying the Preset to one image, then selecting all images and

using the **Sync Metadata** button, or the **Metadata** > **Sync Metadata...** menu command.

In either case the pre-filled Synchronize Metadata window will open, which is similar to the Edit Metadata Presets, then pressing Synchronize will perform the action.

These same Metadata Presets can be applied in the Import dialog box. Way back at the beginning of the chapter when we were applying a Develop Preset to the set of images being imported, we also had the opportunity to apply a Metadata Preset as well as create new ones, and edit those you already have.

Keyword Sets

Keyword Sets are found in the Keywording pane and are used to allow the rapid application of related keywords. There are some general ones provided to start you off. They consist of a concept and some related keywords, for example Wedding Photography.

Here the set contains Bride, Groom, Candid, Wedding Party, Family, Black & White, Pre-Ceremony, Ceremony and Reception. You can quickly apply these Keywords by holding down the Option key and selecting the number adjacent to the Keyword. Groom would be applied by pressing **Option 6**. If the sets you create are well honed this will make applying Keywords that bit faster.

One I tend to use a lot in Insect photography is an **Odonata Keyword Set**. This allows me to apply: Dragonflies, Damselflies, Odonata, Insects, Nature, Cornmill Meadows, Hairy Dragonfly, Common Darter, Common Blue Damselfly.

Unfortunately we are limited to 9 Keywords in a set (so they can be added using the numeric keypad), but there are no limits to the number of sets you are able create.

Export Presets

Export Presets allow you to save a variety of configurations for your common export choices. With the addition of Export plugins, we can create presets which can batch upload your images to any number of online photoservices, such as Flickr or Smugmug. I use Pixelpost to host my photo blog and there is a Lightroom Export plugin which allows me to update my photo blog directly from Lightroom, although it is still under development.

Once you have set up a Preset, you won't have to view the dialog box either; simply selecting **File** > **Export with Preset** > <*Preset Name* > is enough to fire off the images to your selected destination.

In the example below we have installed one of Jeffrey Friedl's Export plug ins, to export to Flickr. Jeffrey is the author of the definitive Regular Expressions book and hosts a blog at **http:// regex.info/blog/**. He has created a number of Export Plugins for the popular services.

The first thing to do is to download and install the plugin. The Flickr Export Plugin can be found at **http://tinyurl.com/5fxlmj**.

Select **File** > **Export**, then click **Plug-In Manager....** Click the **Add** button, navigate to where you downloaded the plug-in. You may be asked to Update your Catalog, which you should do. The plug-in will be installed and you can begin to set up a preset.

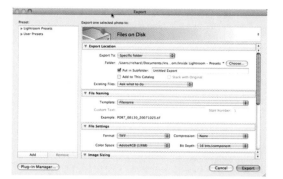

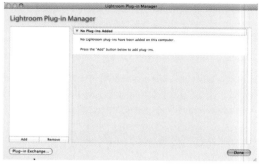

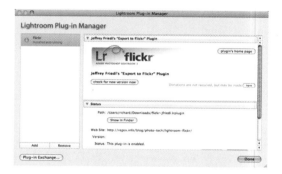

Fig. 6.31 Top Left: The Export dialog box; Top Right: The Plug-in Manager; Bottom Left: Updating the Catalog; Bottom Right: The Flickr Export Plug-in installed.

With Jeffrey's plug-ins, upgrading is handled within the plug-in itself, others may vary.

From the main Export dialog box, select the **Files on Disk** section at the top and scroll to Flickr. If this is the first installation, you will need to authenticate to allow the plug-in to 'speak' to Flickr.

Now proceed to make your settings in the Export plug-in. When you are happy with them, click **Add**, which will create a Preset, by default they will be added to the User Presets folder. In this case we will call it **Flickr One**.

For future exports, just select **File > Export with Preset > Flickr One**. And the upload will take place.

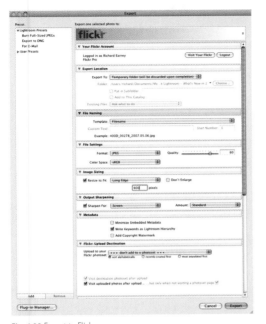

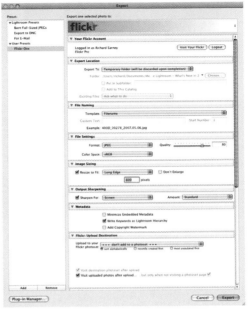

Fig. 6.32 Export to Flickr.

Preset Resources

At the beginning of the chapter, I mentioned the popularity of Presets. Many sites share Develop and Calibration Presets on the Internet. Chapter 7, Lightroom Resources will help you find websites that either offer Presets for free or sell them.

Fig. 6.33 Naming the Preset 'Flickr One'

Fig. 6.34 Simple Export to 'Flickr One'.

171

Lightroom Resources

I have mentioned several times throughout the book that there is a large, and vocal, Lightroom community to be found on the Internet. This chapter will look at the vast array of resources that are out there, to help you learn more, to keep up-to-date and to help you begin to contribute yourself.

This chapter looks at Adobe resources, Tutorial resources, News, Tips and Tricks sites and sites to find Lightroom downloads and complementary applications. Many digital photography forums will have dedicated Lightroom sections, and if you check out your favorite forums you will probably find a niche section devoted to Lightroom.

As you might expect Adobe provides plenty of resources to support Lightroom aside from the Product Page. It is also worth keeping up-to-date with the Adobe Labs site, as you will find that Public Betas are released there. I doubt there will be one for a while, as the full release of Lightroom has just occured, but related applications and plugins are sometimes released to this site, but you never know!

Adobe Resources

Product Page – http://tinyurl.com/35f82f

The first place to start is the Adobe Photoshop Lightroom product page. This is where you can find out how to buy or upgrade, or about special offers that may be available. General announcements, tutorials and special events are also mentioned on the page.

Fig. 7.1 Adobe Photoshop Lightroom Product Page.

Adobe Labs – http://tinyurl.com/y6m9mk

As mentioned, the Labs site is where Public Betas are published and you will find pre-release versions of Adobe Camera Raw features.

Fig. 7.2 Adobe Labs and the Photoshop Lightroom Design Center.

Lightroom Design Center – http://tinyurl.com/6mcyb6

The Lightroom Design Center is the place to find tips, tricks, video tutorials, links to other sites and links to other community resources. It provides the search front end to the Lightroom Community help resource.

Lightroom Community Help – http://tinyurl.com/58shwx

This help resource is an attempt by Adobe to go beyond the standard product help systems. You will find a PDF of the manual here, but better is the fact that it is an online version of help, with user comments and expert moderation.

So if a user feels they can add value to the help system, they can contribute. The higher the quality of contibutions, the greater the value, with the possibility that the user could be upgraded to moderator status. Naturally there is moderation, occasionally Lightroom commentary can be quite heated, and the purpose of this site is to provide real value to users.

You will find me lurking around there doing a bit of light touch moderation as well!

Fig. 7.3 Lightroom Community Help.

Lightroom Support Center – http://tinyurl.com/2ypczt

This is where you will find bugs and troubleshooting information and is probably the first port of call if you are experiencing problems with Lightroom. While the User 2 User forums are also a good place to go, you might find the answer here and that you won't need to run the risk of slightly more 'robust' discussion.

Lightroom User to User Forums – http://tinyurl.com/5dtnyj

Here the biggest discussions take place, here is where you can talk direct to other users, alpha and beta testers as well as the occasional member of the Lightroom and Camera Raw teams.

This is not an official place to speak to Adobe, it is about connecting users to users. If Lightroom team members appear it is because they feel they have something of value to add. They are unlikely to take kindly to direct calls for attention or abuse.

The forums are, as mentioned, robust, so you have to have a thick skin sometimes, but there is also a valuable amount of genuinely useful infomation there. You can often find out about problems that may affect you, you will also see occasional hints dropped about coming soon features.

This is also the place to make Feature Requests.

The forum is moderated by Ian Lyons who does so with a light touch and good humor. Occasionally if things get out of hand he will have to step in and close threads.

Fig. 7.4 Lightroom User to User Forums.

Adobe DevNet – http://tinyurl.com/nnsj9

Here you will find the Lightroom SDK, should you wish to develop for Lightroom, development tutorials are also available.

Fig. 7.5 Adobe DevNet and Adobe TV.

Adobe TV – http://tinyurl.com/64uyg7

A recent addition to Adobe's web strategy, this provides videos on a range of topics, including design and photography. Lightroom is represented in the Photographers' channel.

Lightroom Journal – http://tinyurl.com/2yntcm

The Lightroom team blog here, especially Tom Hogarty, the Lightroom Product Manager. Occasional tutorials are published too.

John Nack on Adobe – http://tinyurl.com/fueyu

The Photoshop Product Manager also has a regularly updated blog, where he shares insight into Adobe's thinking about Photoshop, Lightroom and things photographic, flash and illustration.

Fig. 7.6 Lightroom Journal, John Nack on Adobe, Eric Scouten.

Eric Scouten – http://tinyurl.com/6b4asr

Another member of the Lightroom team, who blogs. Eric has written some interesting posts on workflow tips within Lightroom. It is relatively new, but worth following.

News and Tutorial Sites

There are several sites which are devoted to Lightroom news and tutorials and some that will mention new things amongst other commentary. These are written and contributed to by some of the well-known names in the Photoshop and Lightroom world.

Lightroom News – http://tinyurl.com/5h435o

Set up by Jeff Schewe and Martin Evening (both alpha testers) with Sean McCormack, Ian Lyons, Seth Resnick, Andrew Rodney and Mike Skurski as contributing editors, this is probably the main site to visit for Lightroom information and tutorials. You get a mix of insiders knowledge, visits to Adobe, and extracts from books written by the contributors. It is a sister site to **Photoshop News http://tinyurl.com/596scu**, which performs the same function for the Photoshop world.

NAPP Lightroom 2 Learning Center – http://tinyurl.com/5pd8qd

Another site featuring content from Scott Kelby and Matt Kloskowski and the other Photoshop Guys.

NAPP also hosts a forum, to join you will need to be a member. There are many familiar Lightroom names on the board.

Lightroom Killer Tips – http://tinyurl.com/ykqxwy

Matt Kloskowski, one of the 'Photoshop Guys' has this offshoot of the NAPP (The National Association of Photoshop Professional) site. It contains tip, tricks, videos, tutorials and regularly shares Lightroom Develop Presets with his readers.

Photoshop Insider – http://tinyurl.com/j8ol9

The author and trainer Scott Kelby's blog, which is about Photoshop, Lightroom and photography. Generally interesting, Scott is always keen to share a huge amount of information.

Fig. 7.7 Lightroom News, Photoshop Insider, Lightroom Killer Tips and NAPP Lightroom Learning Center.

Terry White's Tech Blog – http://tinyurl.com/5rsmdr

One more site from a 'Photoshop Guy', this is a more general tech blog, but contains some Lightroom insights.

Lightroom Blog – http://tinyurl.com/6m7rza

Sean McCormack's blog is a testimonial to the amount of hard work he has put into the Lightroom Community. You will find galleries, tips, presets and can follow his quest to find out interesting snippets about the hidden underbelly of Lightroom!

Julieanne Kost's Lightroom Tutorials – http://tinyurl.com/5ojkou

A great range of tutorials for all levels of users from the Digital Imaging Evangelist at Adobe. Covering Photoshop, Lightroom and acting as a resource for some of her amazing photography.

Fig. 7.8 Terry White's Tech Blog.

Luminous Landscape – http://tinyurl.com/btgj

One of the most consistently interesting sites on Photography on the net. Michael Reichmann has a unique perspective on the world of Digital Photography. He also publishes the Luminous Landscape Video Journal, and with Jeff Schewe has produced several in-depth videos on Lightroom, Adobe Camera Raw, and Printing. These are typically reasonably priced and offer great value. Michael is also a Lightroom tester, and the site hosts a forum which contains a Lightroom section.

Computer Darkroom – http://tinyurl.com/pbryq

This is Ian Lyons' personal site (the moderator on the Adobe User to User forum) containing some great photography and articles on Lightroom and Photoshop.

Lightroom Forums – http://tinyurl.com/2ecreo

A comprehensive support forum for Lightroom. Many 'names' have signed up to the forum, you can spot them by the LG (Lightroom Guru) badge against their names. This is a politer place to find out information and get help than the Adobe User to User forums. The only requirements are politeness and to put your system information in your signature.

Fig. 7.9 Julieanne Kost's Lightroom Tutorials, Lightoom Blog, Luminous Landscape, Computer Darkroom.

Lightroom Queen – http://tinyurl.com/5cr6lv

Victoria Bampton who is one of the main moderators on the Lightroom Forums, also has her own site, Lightroom Queen.

Fig. 7.10 Lightroom Forums, Lightroom Queen, Utiliser Lightroom, John Beardsworth, Photography by Frederick Van.

She publishes a troubleshooting Lightroom eBook and if you don't know where to look for Lightroom Keyboard shortcuts, this is certainly the place to visit.

Utiliser Lightroom –http://tinyurl.com/6b62sh

This French site is run by Gilles Theophile, offering help, forums, tips and tricks for French and French-speaking Lightroom users.

John Beardsworth – http://tinyurl.com/okgg4

John Beardsworth, author, photographer and DAM consultant, offers a distinctive voice on the issues surrounding Lightroom. He provides commentary and tutorials on Lightroom and photography, and delves in to the underbelly of why Lightroom works the way it does.

Photography by Frederick Van – http://tinyurl.com/5n3kxy

Lightroom tips and tricks are provided by Frederick V. Johnson, as well as video interviews with Lightroom and Photoshop engineers such as Phil Clevinger and John Nack. You might spot his name on the Lightroom startup screen as well.

O'Reilly Media – Inside Lightroom – http://tinyurl.com/s3dnb

Following on from their success with the *Inside Aperture* blog, O'Reilly Media produced the *Inside Lightroom* blog. This offers a range of voices blogging about specific Lightroom topics and tips. No relation to my site or this book; just a coincidence. O'Reilly was one of the sponsors of the first Lightroom Adventure to Iceland, **http://tinyurl.com/5s4jyd**, which took place during

the public beta of version 1.0. They repeated the experience with a second adventure to Tasmania, **http://tinyurl.com/5s4jyd**, during the public beta of version 2.0.

Lightroom Galleries – http://tinyurl.com/3srg6o

A great resource for Lightroom Galleries (as you would expect!) produced by Joe Capra. Hosting several useful galleries including the LR Complete gallery, mentioned below.

Outdoor Images – http://tinyurl.com/6xbwsp

A blog run by David Knoble, with tips and tricks on Lightroom. The site also hosts a user guide to the LRG Complete web gallery, which includes PayPal and Google Checkout facilities.

The Turning Gate – http://tinyurl.com/6fn9b6

Matthew Campagna hosts this site, which also offers users a selection of web galleries, including the Polaroid and Postcard galleries.

Fig. 7.11 O'Reilly Media-Inside Lightroom, Lightroom Galleries, Outdoor Images, The Turning Gate.

Fig. 7.12 SlideShowPro, OnOne PhotoPresets, Inside Lightroom.

Fig. 7.13 Pro Photography Show, Heather Green.

SlideShowPro – http://tinyurl.com/ywbam9

SlideShowPro for Lightroom is a comprehensive Flash-based web gallery, created by Todd Dominey. Highly extensible; there are some great examples on the site of the possible variations.

OnOne PhotoPresets – http://tinyurl.com/5ndv5j

Designed to provide you with a streamlined workflow, these 85 presets for Lightroom were designed by Jack Davis to help you get the most out of Lightroom. Organized and setup in a traditional workflow, these presets will help you quickly set the correct white balance, choose a tone curve, adjust vibrance, HSL, convert to black and white and add a vignette.

Inside Lightroom – http://tinyurl.com/62ftf3

Modesty would normally prevent me from mentioning my own site, but it is a resource for over a hundred Presets that have been generated by Lightroom users, developers and testers. It will also act as an update resource for this book. New Presets are always welcome; use the submit link at the top left of the site.

There are also two sites that are 'meta lists' of where to find more Develop Presets.

Pro Photography Show – http://tinyurl.com/36l78a

Pro Photography Show is a resource for professional photographers, containing tips and tricks as well as offering podcasts. The link above contains a list of where to find presets. PPS also sell a few Presets of their own.

Heather Green – http://tinyurl.com/3brd7z

Although this site is mostly about her Photography, she also keeps a meta list of Preset sites.

Both of these are updated as new Presets appear.

Jeffrey Friedl – http://tinyurl.com/5vns96

Jeffrey Friedl is the guru behind O'Reilly's Mastering Regular Expressions, and many Lightroom resources. Jeffrey has written several utlities for Lightroom, a collection of Export Plug-ins, for photo sites, such as Flickr, SmugMug, Facebook, Picassa and Zenfolio. He has also contributed the Metadata Wrangler, and the Lightroom Configuration Manager.

Timothy Armes

Like Jeffrey has created some useful export plug-ins for Lightroom, **LR/Mogrify**, **LR/Transporter** and **LR/Enfuse**.

Fig. 7.14 Jeffrey Friedl and Timothy Armes.

Fig. 7.15 Apple iTunes podcasts.

Mogrify, **http://tinyurl.com/3ao3vm**, acts as a front-end to the open source *ImageMagick* utility. ImageMagick is a collection of powerful, freeware command line utilities for processing images. Transporter, **http://tinyurl.com/6o9w2t**, allows you make use of the metadata embedded in your photos. Enfuse, **http://tinyurl.com/5jtc7u**, provides a convenient interface onto the open source *Enfuse* application, which provides excellent blending of multiple exposures of the same scene into one final image.

Podcasts

George Jardine – http://tinyurl.com/5qb98b

George Jardine was the former Digital Photography Evangelist for Adobe, and was involved in the early days of the Shadowland project which eventually became Lightroom. He produced 53 Podcasts relating to Lightroom and Photography. Early on there were interviews with the Lightroom Team and those involved with creating Lightroom, then he produced Video Podcasts, Video Tutorials, and interviews with renowned photographers. He recently left Adobe to find some new inspiration, but his legacy is some exceptionally interesting material relating to Lightroom. His blog contains details about the podcasts, and they are available on Apple's iTunes, **http://tinyurl.com/6p8e6b**.

Killer Tips Podcast – http://tinyurl.com/387w45

Matt Kloskowski of the Lightroom Killer Tips blog, also produces the Killer Tips podcast.

Lightroom for Digital Photographers – http://tinyurl.com/6k25u7

Michael Rather produces these step-by-step podcasts taking you through the application.

Photgraphy by Frederick Van – http://tinyurl.com/5g5tpm

A companion site to his blog, Frederick V. Johnson, has interviews with Lightroom alumni and other podcasts relating to photography and Lightroom.

General

Two other sites are less Lightroom specific, but either have relevance to Lightroom or DAM techniques. The DAM Forum, **http://tinyurl.com/69xtvr**, contains support for Digital Asset Management issues. ImageIngester Blog, **http://tinyurl.com/6j6u3a**.

Fig. 7.16 The DAM Forum and ImageIngester Blog.

Flickr

The photo site Flickr hosts 3 main groups relating to Lightroom, there is a main **Adobe Lightroom** help forum **http://tinyurl.com/5zwgq5** and two forums devoted to Lightroom Develop Presets, **Presetting Lightroom**, **http://tinyurl.com/5zwgq5**, and **Kelsey Smith's LIghtroom Presets, http://tinyurl.com/57chwt**.

Fig. 7.17 Three Flickr forums.

187

Fig. 7.18 Bluefire Blog.

Bluefire Blog – http://tinyurl.com/5cy7l8

A site all the budding web gallery creators out there, that is on the periphery of Lightroom, but still has relevance is the Bluefire Blog. They focus on matters relating to Adobe gallery creation, both for Lightroom and other Adobe products. The Bluefire team has developed many galleries using the various technologies that Adobe have to offer.

As you have seen in this chapter, there are a lot of Lightroom reources. It can be hard to keep a track of all that is going on and keep up to date. One way is to use an RSS Reader as most of the sites mention offer RSS or Atom feeds. On the Mac, I recommend **NetNewsWire** from Newsgator and for Windows **FeedDemon**, also from NewsGator. But there are many readers available.

Keeping Track

I have created a set of feeds which track all the sites offering them that are mentioned above, and this can be downloaded from **http://tinyurl.com/4n9t79**.

To use this you will need to unzip the download, and then import the Lightroom.opml file into your news reader, (see your news reader's help file).

Fig. 7.19 NetNewsWire and FeedDemon.

Basic Troubleshooting

Lightroom should be fairly stable, but there are always occasions where things may not go according to plan.

This is not intended as a comprehensive guide to troubleshooting, but will cover the basic steps and some common problems that have occurred since the release of version 2.

Repeated crashing or not starting

If you are suffering from repeated crashing or Modules that don't seem to work, then isolating what might have caused the crash is of paramount importance. The first step is always to remove the Preferences file, as it is possible this may have been corrupted at some point.

I will assume that Lightroom is closed (if you are constantly crashing, it probably will be!) Then locate the preferences file. Depending on your Operating System it will be located in the following places:

Mac: `~/Library/Preferences/com.adobe.Lightroom2.plist`Windows XP: `C:\\Documents and Settings/<username>\Application Data\Adobe\Lightroom\Preferences\Lightroom Preferences.agprefs`
Windows Vista: `Users\<username>\AppData\Roaming\Adobe\Lightroom\Preferences\Lightroom Preferences.agprefs`

Move, or rename the file, then restart Lightroom. The Preferences file will be rebuilt and hopefully this will cause Lightroom to start behaving well. If there are still problems, then you might have a corrupt Preset file.

Any Presets that have been hand edited can cause problems, if that editing made a tiny error, a missed semi-colon or comma, then the Preset may be corrupted. This can cause crashes or Modules to cease working. Removing Presets in batches and trying to start Lightroom again, can help you isolate which Preset may be corrupt. See Chapter 6 for more information on the location of Presets.

Catalog Corruption

Very occasionally, your Catalog (database) may become corrupt. If so you will receive a message to that effect from Lightroom. If you follow the advice laid out in Chapters 2 and 4 relating to backup and archiving, you will hopefully have a recent backup

of your Catalog. If not then the chances are this catalog can be rescued, so don't be tempted to throw it away! Instead it is worth sending a compressed (preferably zipped) copy of the .lrcat file to dtull@adobe.com. He can generally perform magic, but only do this if you are sure there is a problem and you are in danger of losing a large quantity of work. While Adobe are interested in damaged Catalogs, they are unlikely to be happy with lots of people sending them Catalogs for the sake of it!

Slow Operation

It is quite possible that with the upgrade to version 2 that you may experience some slowdowns. There will probably be a fix for most of these in the work and it may even be released by the time you read this.

It is worth ensuring that you are running the latest version of Lightroom. When you first installed Lightroom you were asked if you wanted to be kept up-to-date, hopefully you said yes, but if not then you can achieve this manually by selecting **Help** > **Check for Updates…**.

Some users have found that removing an older version of Lightroom is beneficial, and it is definitely worth removing any Public Betas of Lightroom 2 from your system.

Another way to speed up Lightroom 2 has been to delete all your Preview files and regenerate them. More information on Previews can be found in Chapter 4, but if in the Library Module, you select Library > Previews > Discard 1:1 Previews…, then select Library > Previews > Render 1:1 Previews, this will regenerate the Previews, and you may find a beneficial speedup occurs.

If you are making heavy use of the Adjustment Brush, and making several separate masks, you may find that reducing the number of masks will make Lightroom faster. The more Metadata edits you create can have an adverse affect on Lightroom's speed.

Missing Keywords

This is a known bug with an upgrade from version 1.x to 2.0. When you export from version 2 you may find that keywords that existed in version 1 are not exported. There is an approved fix for this which is documented at **http://tinyurl.com/4gekpv**.

Edit in Photoshop does not start Photoshop

If you try to **Edit in Photoshop CS3** from Lightroom 2 and Photoshop CS3 doesn't open, or after Photoshop opens, you see an error message, 'Photoshop could not be launched', this can be caused by several factors. At the time of writing there is not a confirmed fix for this bug, but there are several steps to try. These are documented at **http://tinyurl.com/5vaqoe**.

Support Resources

These are the major problems that have surfaced in the first month since Lightroom 2 was released. For more information on these and any other problems, it is worth keeping an eye on the Adobe User to User forums, and the Lightroom Support Center **http://tinyurl.com/2ypczt**, as mentioned at the beginning of this chapter.

Up to Speed

If you still find that Lightroom 2 is too slow, you may be running an outdated computer setup, in which case you might need to upgrade, or at least think about upgrading, your system.

Lightroom is a resource intensive application, so running it on an ill-equiped system will prove to be a frustrating experience and may be costing your business time and money.

If you are starting from scratch, then Chapter 2, The Ideal System, will help you make some decisions that can build you a Lightroom dream machine. Even if you are not ready to make the leap to buy a new computer, you will find some general principles in getting the most from your current setup.

Index